PORTRAIT OF

MOUNT ST. HELENS

A CHANGING LANDSCAPE

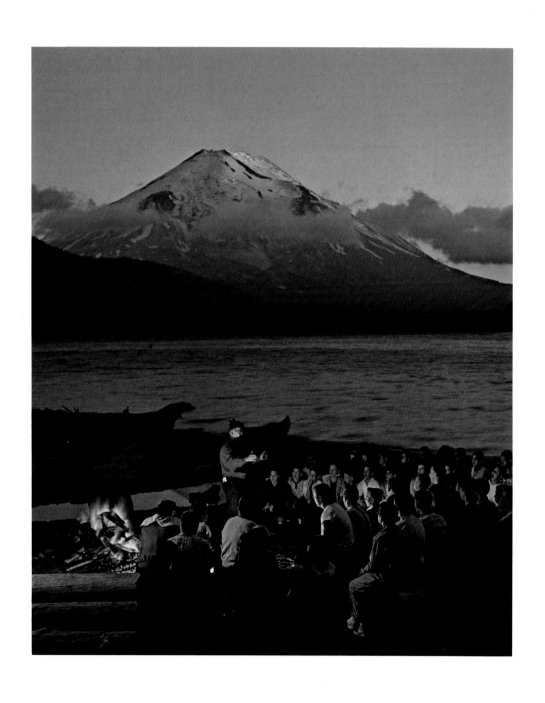

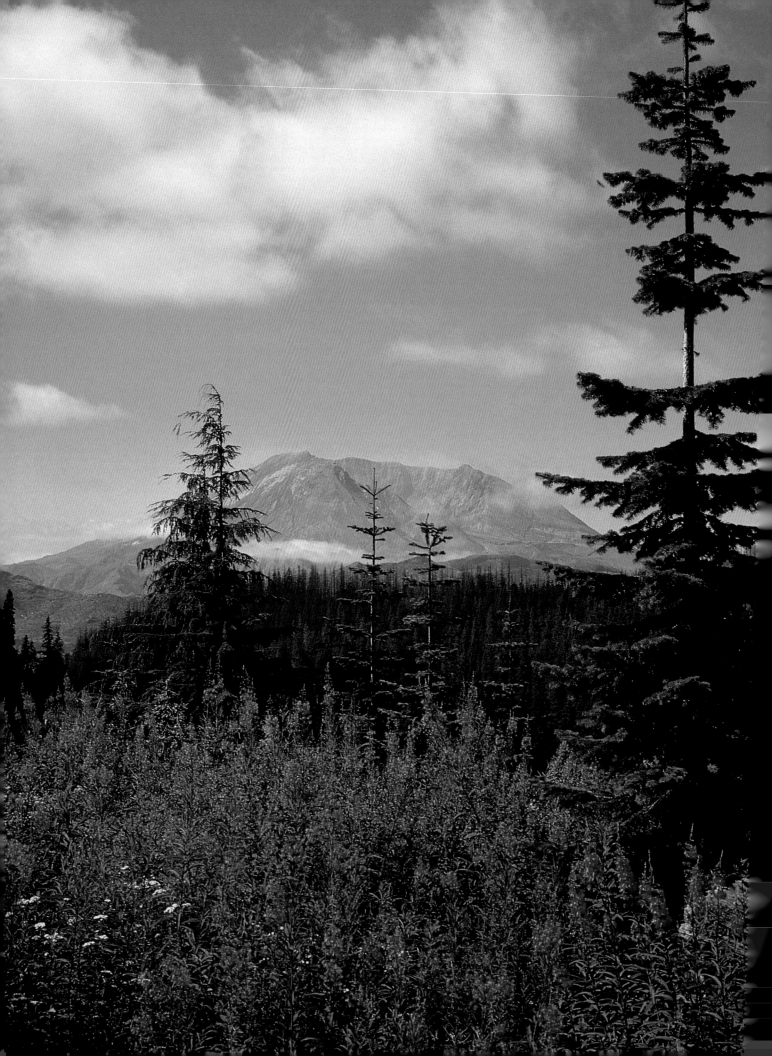

PORTRAIT OF

MOUNT
ST. HELENS
A CHANGING LANDSCAPE

Essays by
Chuck Williams
and Stuart Warren

GRAPHIC ARTS CENTER PUBLISHING®

International Standard Book Number 1-55868-310-0
Library of Congress Catalog Number 97-70189
Essays and compilation of photos © MCMXCVII by Graphic Arts Center Publishing Co.
P.O. Box 10306 • Portland, Oregon 97296-0306 • 503/226-2402
No part of this book may be reproduced by any means whatsoever
without the written permission of the publisher.
President • Charles M. Hopkins
Editor-in-Chief • Douglas A. Pfeiffer
Managing Editor • Jean Andrews
Photo Editor • Diana S. Eilers
Production Manager • Richard L. Owsiany
Book Manufacturing • Lincoln & Allen Co.
Printed in the United States of America

◆

Every effort has been made to contact those whose images appear in this book. If the publisher has not been able to locate a photographer whose image has been used, we request that you contact us. Following are the photo page numbers with credit indicated for the photographers who took the images: • Front jacket upper photo, pages 1, 10, 17, 18, 24-25, 49, and 50 © Ray Atkeson • Page 6 top photo Courtesy G. T. Benson Collection • Page 55 © Gary Braasch • Page 46 © Bruce Curtis • Pages 26 and 27 all photos © Walt Dyke • Pages 2, 61, and 67 © Don Eastman • Page 6 lower photo © Charles W. Embody/Courtesy Donald B. Lawrence Collection • Pages 37, 44-45, and 52-53 © Glen Finch • Page 20-21 © John Gronert • Pages 28-29 and 30 © Al Hayward • Page 63 lower photo © Kirkendall-Spring/Borland Stock Photo • Pages 66, 80, and back jacket photo © Jeff Krause/Borland Stock Photo • Front jacket large photo and page 47 © Russell Lamb • Pages 64 top photo, 68, and 69 © Tom and Pat Leeson • Page 62 © Harvey Lloyd • Page 14 top photo © C. L. Marshall/Courtesy The Marshall Collection • Front jacket lower photo, pages 23 top photo, 34, 72, 74, 75, 76-77, 78 both photos, and 79 both photos © John Marshall • Pages 22, 43, and 56-57 © James Mason • Page 13 lower photo Courtesy The Mazamas • Page 14 lower photo Courtesy The Mountaineers • Page 8-9 © David Muench • Page 54 © Ancil Nance • Page 48 both photos by NASA-Ames Research Center/Courtesy U.S. Forest Service • Page 33 © Dave Olson • Pages 40 both photos and 41 both photos © Gary Rosenquist • Page 5 Courtesy Royal Ontario Museum • Pages 60, 65, and 73 © Rick Schafer • Pages 38 and 39 © K & D Stoffel • Pages 58, 59, 70, and 71 © Tim Thompson • Pages 63 top photo and 64 lower photo © Mark Turner • Page 13 top photo Courtesy U.S. Forest Service • Page 7 Courtesy Special Collections and Preservation Division, University of Washington Libraries, photo by A. C. Warner • Pages 42 and 51 © Roger Werth/Woodfin-Camp • Page 23 lower photo © Art Wolfe.

◆

*Stuart Warren, author of the chapter entitled, "Eruption and Resurrection,"
would like to give special thanks to Ernie Parrott and his family and
friends, who shared so generously of their wealth of information.*

Half Title Page: Portland YMCA members enjoyed many cozy campfires at Camp Meehan on the north shore of Spirit Lake. *Frontispiece:* Purple fireweed and white pearly everlasting are among the most eye-catching presences in the charred soils of Mount St. Helens' ecosystem. When the fireweed loses its petals, Native peoples will tell you winter is near.

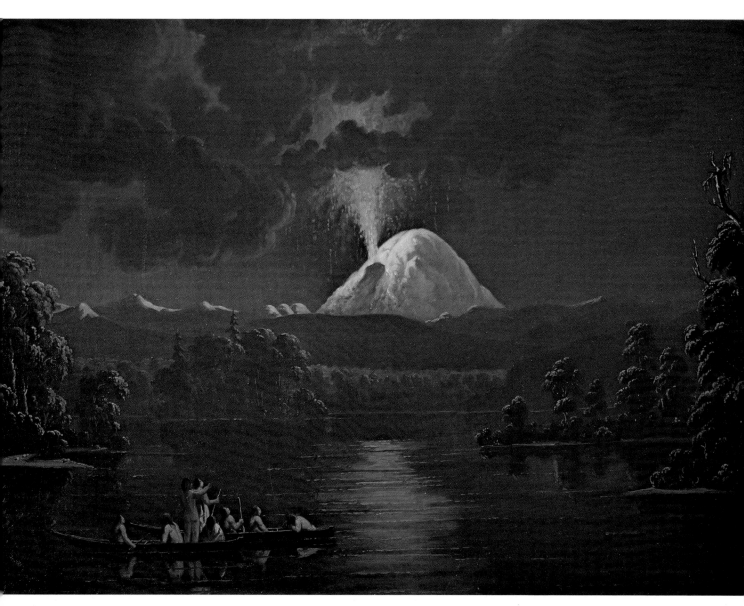

△ Paul Kane, a Canadian artist, visited the Northwest in 1847. He wrote: "There was not a cloud visible in the sky at the time I commenced my sketch, and not a breath of air was perceptible; suddenly a stream of white smoke shot up from the crater of the mountain and hovered a short time over its summit; it then settled down like a cap." Kane painted this nighttime scene after he had returned to Canada, basing it on secondhand reports of the 1842-1844 eruptions.

Mount St. Helens

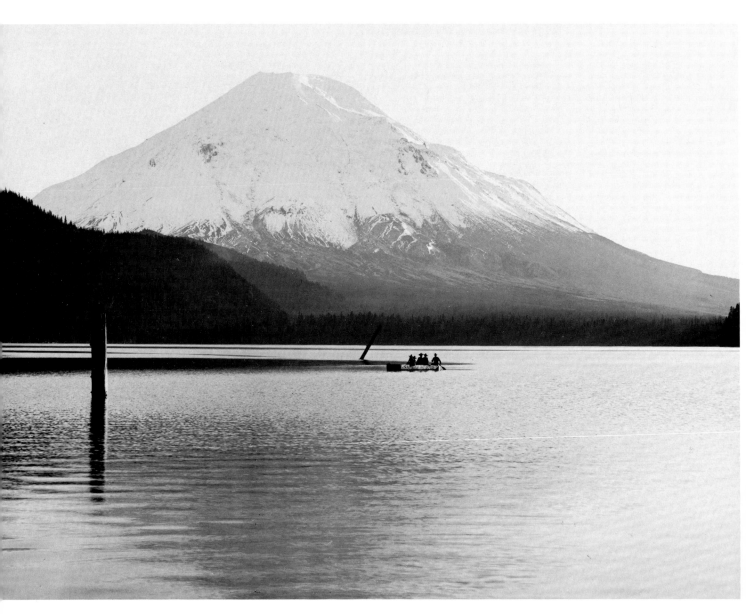

△ △ The second known drawing of Mount St. Helens (indicated above) shows a shortened summit, probably due to cloud cover when it was sketched by Harry Humphrys, during George Vancouver's 1792 survey of the northwest coast.

△ Charles Embody brought his nieces for "an experience they would never forget." This photo of the party on Spirit Lake in 1897 or 1898 shows drowned trees, the result of a mudflow about A.D. 1500, which raised the lake's level over sixty feet.

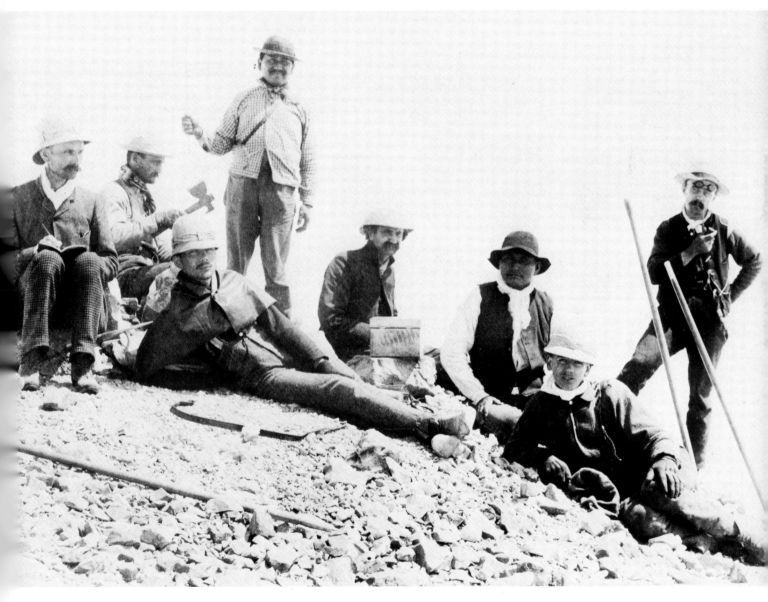

△ The Oregon Alpine Club, the first outdoor club to ascend Mount St. Helens, reached the summit on July 26, 1889. This photograph of the party is probably the first picture ever taken on the summit of the mountain. The earliest recorded ascent was made by Thomas J. Dryer, first editor of *The Oregonian,* with three others in 1853. The two-week trip from Vancouver was by horseback along the newly cleared Lewis River trail, then by foot up the south slope.

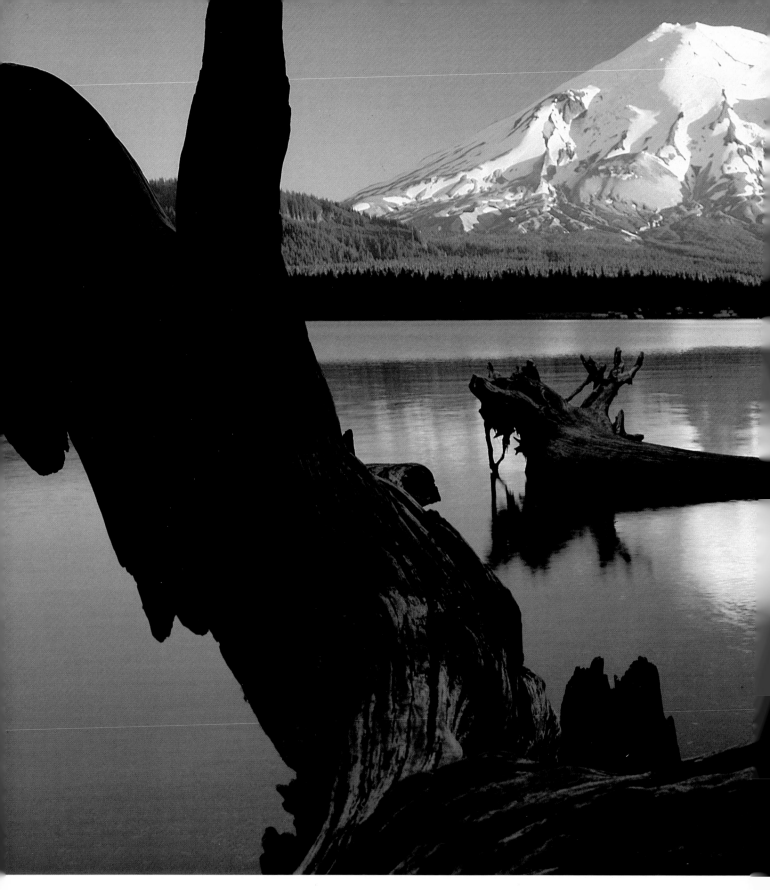

△ For the past century, Mount St. Helens has been famed primarily for its beauty. It did not reach as high as the other major volcanic cones that crown the Cascade Range (9,677 feet before eruption compared with Mount Rainier's 14,411 feet and Mount Hood's 11,239 feet). However,

Mount St. Helens' youthful symmetry stood out among the older, more weathered peaks. Its beauty was especially striking in winter; with a glistening white coat of snow, it hovered over the dark, evergreen horizon like a mirage, seemingly too perfect to exist except perhaps in our minds.

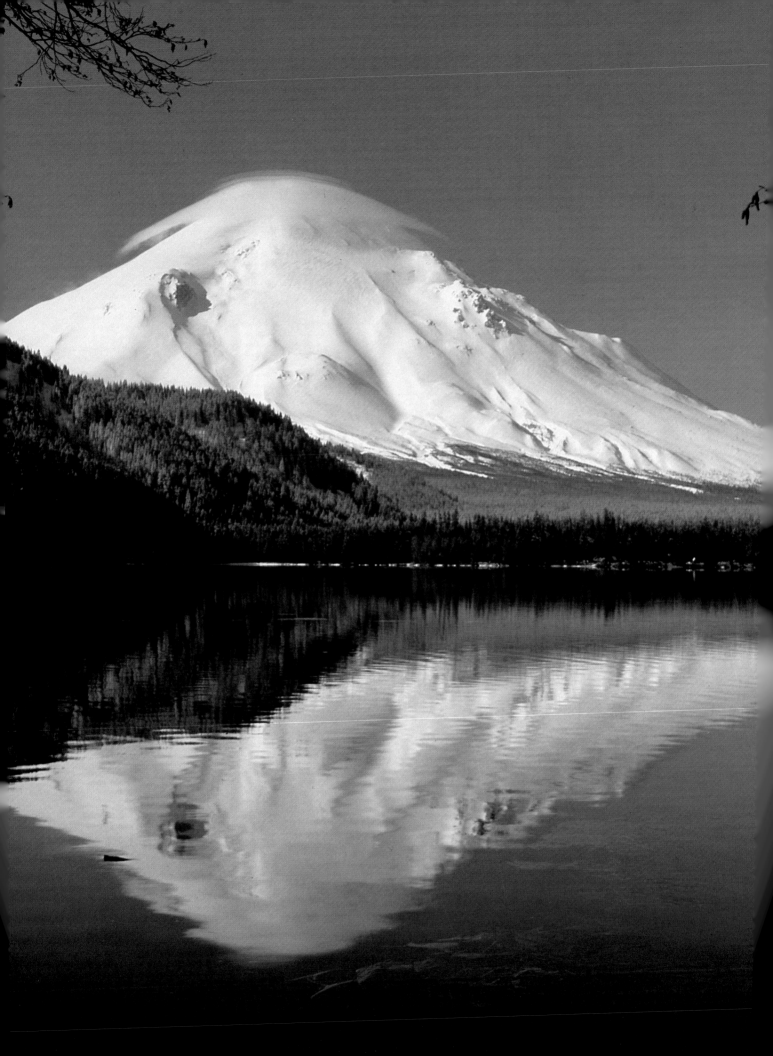

Keeper of the Fire
by Chuck Williams

Human occupation near Mount St. Helens is a recent phenomenon. The volcano is young and active, and the Native Americans of the region avoided Spirit Lake and Mount St. Helens, especially above timberline. When Canadian painter Paul Kane traveled through the Northwest in the mid-1800s, he sketched eruptions from the Columbia and Cowlitz Rivers, but was unable to find an Indian willing to guide him to Spirit Lake and the volcano.

Mount St. Helens rose in a rugged, little-used land between three diverse prehistoric cultures: the Salish-speaking people of Puget Sound and what became northern Washington, the Sahaptin-language people of the plateau east of the Cascades, and the Chinookan-speaking residents of the lower Columbia. Important Chinook settlements near the volcano included the Cathlapotle village at the mouth of the Lewis River and the Skilloot villages near the mouth of the Cowlitz. The Indian peoples known as the Cowlitz were united politically but were actually two distinct groups. The residents along the lower and middle Cowlitz River were Coast Salish, while the Taidnapam, or Upper Cowlitz, who lived directly north (and probably south) of the volcano, increasingly spoke Sahaptin, although Salish culture and bloodlines continued to dominate. The Klickitat Indians, who resided between Mount St. Helens, Mount Adams and the Columbia Gorge, spoke Sahaptin and were closely related to the Yakimas.

Each tribe in the vicinity of Mount St. Helens had its own name for the peak and its own legends regarding the mountain's history. *Loo-wit,* now the most commonly used "Indian" name for Mount St. Helens, is probably anglicized; other names include *Lawelatla* ("One From Whom Smoke Comes") and *Tah-one-lat-clah* ("Fire Mountain").

The best-known legend involving the volcano is the story of the Bridge of the Gods and the creation of the Columbia Gorge. In most versions, Mount Hood and Mount Adams, sons of the Great Spirit, fought over a beautiful female mountain. The brothers shook the earth, blocked the sunlight, threw fire at each other, burned the forests, drove off the animals and covered the plants needed by the people with ash. The fight cracked the Cascade Range, forming a canyon and a tunnel which emptied the huge lake east of the mountains. The Great Spirit returned and was furious. He left the Bridge of the Gods, the stone arch over the Columbia River, as a monument to peace and placed an elderly, weathered female mountain, Loo-wit, at the bridge as a peacemaker—and as a reminder to the brothers of how transient youthful beauty is. Loo-wit was the keeper of the fire, which had been stolen from atop Wy-east (Mount Hood) by Coyote the Trickster.

Slowly the scars of the battle healed; the green forests returned, and the brothers again wore white coats. But after many years of happiness, jealousy between the brothers again erupted into battle. The earth shook so hard that the Bridge of the Gods fell into the river, creating the Cascades of the Columbia. Loo-wit tried to stop the fight, but she was badly battered and fell into the river. As a reward for her bravery, the Great Spirit gave Loo-wit one wish; she replied that she would like to be young and beautiful again. The Great Spirit granted her wish but told her that her mind would have to remain old; Loo-wit replied that she preferred it that way. Since nearly all of her friends had passed away and had been replaced by young upstarts, she moved off by herself, away from the other mountains.

In some versions of this much-altered legend, Mount St. Helens is the beautiful woman that the brothers fought over; in others, she is the hot-tempered wife of Mount Hood. Among the Cowlitz who lived northwest of the volcano, the battle was between Mount St. Helens and Mount Rainier.

The Natives who lived along the streams below Mount St. Helens seasonally visited the mountain's wooded flanks to hunt, fish and collect plants; temporary camps were made during these expeditions. However, only youths on spirit quests—those who were seeking exceptionally powerful guardian spirits—ventured as far up as timberline. Spirit Lake was off-limits; it was the home of an outlaw band of demons, a Hell of sorts. The salmon in the lake were thought by many to be the ghosts of the evilest people that ever lived. If one of these wicked *Seatco* was caught, the others would murder a dozen people from the fisherman's tribe. The local Indians claimed that near Spirit Lake loud moans often filled the air

◁ *From Harmony Falls, the deep, cold water of Spirit Lake holds the reflection of Mount St. Helens. Because of its* symmetrical cone and gracefully sloping northwest side, the mountain was often compared with Japan's Mount Fujiyama.

and waterfalls could be heard in areas where none existed. Later versions of these legends often claimed that the evil spirits at the lake were punishing the local tribes for allowing the white people into the land.

European exploration of the Northwest began in earnest near the end of the 18th century, when the abundance of fur-bearing animals, especially sea otters and beavers, attracted trading ships from around the world. A British explorer, George Vancouver, sighted Mount St. Helens in 1792 and gave the peak its present name in honor of a noted British diplomat, Alleyne Fitzherbert, the Baron of St. Helens (a city near Liverpool).

The next *recorded* sighting of Mount St. Helens was by the Lewis and Clark Expedition in 1805. Lt. William Clark was fascinated by the mountain; he wrote that it rose "something in the form of a Sugar lofe" and was the "most noble looking object of its kind in nature." During the years between the visits of Vancouver and Clark, Mount St. Helens had a major eruption; but it went unmentioned by the fur traders, possibly because of the region's notoriously cloudy weather. However, the huge eruption around 1802 spread ash across what later became eastern Washington and Idaho, and the ashfall became part of the oral tradition of the affected tribes. In the mid-1800s, missionaries at the Tshimakain Mission (near Spokane) recorded stories told among the local tribes about the time, decades earlier, when ash "fell to the depth of six inches" during "a very long night with heavy thunder." Scientific evidence only recently confirmed that earlier turn-of-the-century eruption.

The Kalispel of northern Idaho told of the afternoon when "it rained cinders and fire." The tribe "supposed that the sun had burnt up, and that there was an end of all things. The next morning, when the sun arose, they were so delighted as to have a great dance and a feast."

The Sanpoil were so frightened by the ashfall that "the whole summer was spent in praying. The people even danced—something they never did except in winter." The nearby Nespelem were afraid that the ash "prognosticated evil"; they "prayed to the 'dry snow,' called it 'Chief' and 'Mystery' and asked it to explain itself and tell why it came."

A Spokane chief told members of the United States' 1841 Wilkes Expedition that his people thought the ash meant "the world was falling to pieces." The most respected medicine man assured the tribe that the world was not ending—at least not yet. But he warned them that: "Soon there will come from the rising sun a different kind of men from any you have yet seen, who will bring with them a book, and will teach you everything, and after that the world will fall to pieces." Other Spokane accounts told of a strong earthquake and the starvation of many people during the harsh winter that followed the ashfall.

The world soon fell apart for the Native Americans near Mount St. Helens; they were decimated by the diseases brought by the white newcomers. The combination of a smallpox epidemic about 1790 and a wave of malaria or flu around 1830 killed over ninety percent of the Natives living west of the mountain; measles increased the toll. The more nomadic tribes east of the Cascades were generally less affected, and the Klickitats increasingly used the lower Lewis River watershed and replaced the Chinooks as the region's most important traders, the "middle-men" between coastal tribes and the famous Long Narrows/Celilo Falls trade mart.

The Canadian North West Company forced out U.S. and European competitors and controlled the fur trade until 1821, when it was absorbed—under orders from Britain—by the Hudson's Bay Company, which moved the regional headquarters upriver to Fort Vancouver. In the 1830s, Nathaniel Wyeth and other entrepreneurs from the U.S. failed in their efforts to compete with the British in the Northwest—but brought with them Protestant missionaries who, as it turned out, were better colonizers than preachers. The Catholics countered by sending missionaries to British outposts, including the Hudson's Bay Company farms at Cowlitz Landing (near Toledo), the start of the overland portage trail which connected the Columbia River system to the Nisqually arm of Puget Sound.

Pioneers from the United States, who made the great trek across the Oregon Trail and settled in the valleys west of the Cascade Range, ultimately brought an end to British domination of the Northwest. Hall J. Kelley, the most vocal promoter of U.S. colonization of the Northwest, wanted to change the name of the Cascades to the Presidential Range; under his scheme, Mount St. Helens would have become Mount Washington.

The first recorded eruption of Mount St. Helens was in 1835, when Meredith Gairdner, a physician at Fort Vancouver, noted ashfall during a couple of unusually hazy days. He found "the mountain destitute of its cover of everlasting snow" and saw what "appeared to be lava flows" through his telescope. Gairdner wrote that there was a similar period of haze in 1831, which, in retrospect, he thought was also an eruption.

Then on November 22, 1842, Reverend Josiah L. Parrish was in a meeting at Champoeg, the site of the Methodist mission on the lower Willamette River. He stepped outside and noticed that Mount St. Helens was erupting, but when he told Jason Lee and the other missionaries still inside, they "laughed the idea to scorn." Finally, the men stepped outside, where they "saw arising from its summit, immense and beautiful scrolls of what seemed to be pure white steam, which rose many degrees into the heavens," while down next to "the mountain's top the substance was black as ink."

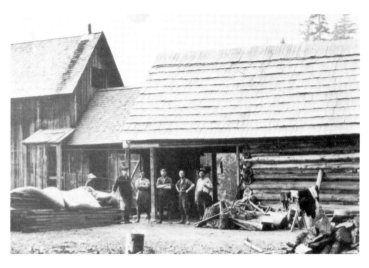

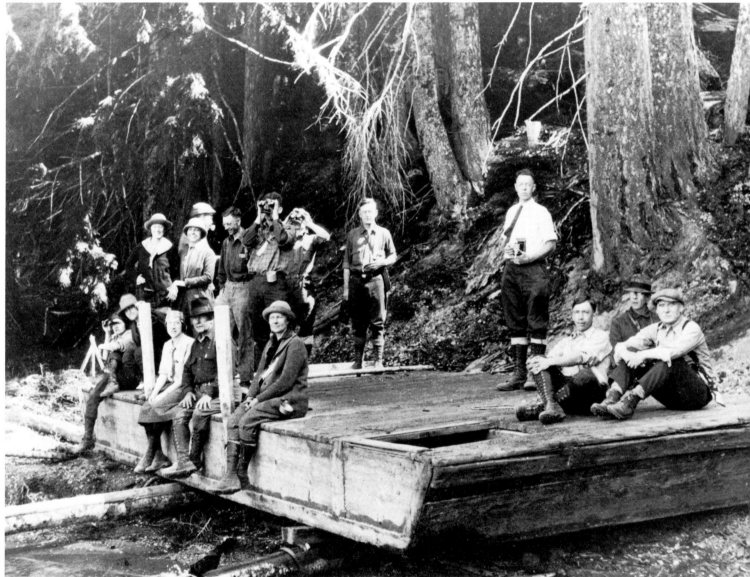

△ △ Robert C. Lange started his homestead in 1879, just a mile down the Toutle River from Spirit Lake. In 1901, a wagon road was built to the lake. Lange established a trading post at his homestead, and a telephone line reached it in 1906.

△ In 1925, members of the Mazamas pose on an ore barge beached near the Sweden Mine. The barge was constructed in the winter of 1901-1902 to carry machinery and ore across Spirit Lake. Remnants of the barge were still visible in 1979.

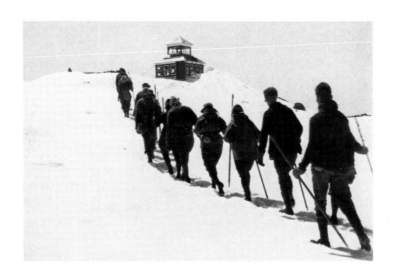

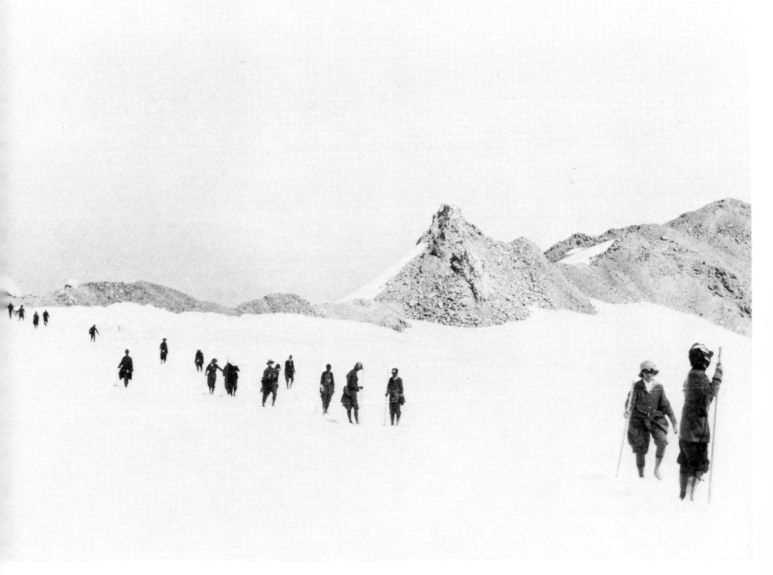

△ △ Constructed on the summit of Mount St. Helens during the summer of 1917, the lookout cabin featured reinforcement against heavy snow and a firefinder in a glass-enclosed cupola. At this elevation, haze and bad weather conditions caused poor visibility, so the lookout was last manned in the summer of 1927; it was boarded up in 1928. △ On the south rim, Chimney Rock stood sentinel as a party of Mountaineers crossed the snow-filled summit crater in 1917.

The following day, Parrish "noticed that she had changed her snowy dress of pure white for somber black mantle." He later wrote that "flames were seen for a long time issuing from a crater on the south side of the mountain, two-thirds of the way up." Further eruptions over the next few days dumped ash from the Pacific Ocean to The Dalles, where "the winds had wafted its ashes to the door of the missionaries." Daniel Lee, the founder of the Wascopam Mission at The Dalles, noted the smell of sulphur and wrote that "a dark, heavy cloud was seen rising in the direction of Mount St. Helens," but "no special remark was excited by this fact." However, the missionaries arose the next morning to find that "the ejected ashes were falling with a mist-like appearance, covering the leaves, fences, and stones with a light, fine, gritty substance, in appearance like hoar frost, some specimens of which were collected." These specimens were given to U.S. Army explorer John C. Fremont the following year, but he later lost them during a flash flood in Kansas on the way back to the East.

Another Methodist missionary, Elijah White, wrote that "immense quantities of melted lava were rolling down its sides, and inundating the plains below." This account is no doubt exaggerated, but there are other eyewitness reports of lava flows during this series of eruptions. An early pioneer reported than an Indian deer hunter had badly burned a leg trying to jump a lava flow and was treated at Fort Vancouver, but the doctors at the fort were later unable to recall such an event. There were numerous reports of dead fish in the Toutle River during these eruptions, and a French-Canadian voyageur living along the lower Toutle claimed that "the light from the burning volcano was so intense that one could see to pick up a pin in the grass at midnight near his cabin, which is some 20 miles distant." The Oregon City *Spectator* reported that both Mount St. Helens and Mount Baker (in northern Washington) erupted in 1850.

The major eruptions of this cycle occurred during the years of 1842-44, but sporadic volcanic activity lasted until 1857, when Mount St. Helens finally calmed down again. Even before the 123-year period of relative dormancy began, the first party of climbers reached the summit. In the summer of 1853, Captain George McClellan and his U.S. Army survey expedition (including geologist George Gibbs) cleared out the old Klickitat Trail, which went up the Lewis River drainage and crossed the Cascades south of Mount Adams; he found some Native villages along the Lewis and a fishing camp above the present town of Yacolt. At this time, there were still Cowlitz Indians living up the Lewis River who had never seen white people. Most newcomers went to the Willamette Valley, although a few settled along the Cowlitz River and the overland portage. (There were settlers at Woodland as early as 1845.) Another trans-Cascade

route, the Yakima Trail, went up the Cowlitz River and crossed the divide north of Mount Adams.

The earliest recorded ascent of Mount St. Helens was in August 1853 by a group of four men led by Thomas J. Dryer, the first editor of *The Oregonian*. The two-week trip from Vancouver was made by horseback along the newly cleared Lewis River trail, then by foot up the south slope, which Dryer called "sublimely grand and impossible to describe." Nevertheless, the newspaperman wrote of "blackened piles of lava which were thrown into ridges hundreds of feet high in every imaginable shape of primitive formation." Dryer felt that the mountain was "seeming to lift its head above and struggling to be released from its compressed position," which "impressed the mind of the beholder with the power of omnipotence and the insignificance of human power when compared to that of Nature's God."

By the time Dryer's party climbed the volcano, the crater on the south side, which was described by witnesses to the 1842-44 eruptions, had disappeared beneath snow and the forming glaciers. Dryer did see a crater on the northwest flank and wrote that "smoke was continually issuing from its mouth." In 1854, six months after the ascent, *The Oregonian* updated their coverage, reporting that there was "more smoke issuing from it than there was then, which indicates that the volcanic fires are rapidly increasing within the bowels of this majestic mountain." The last known eruption of this cycle was in April 1857, when the *Washington Republican* reported from Steilacoom that the peak had "for the last few days been emitting huge volumes of dense smoke and fire, presenting a grand and sublime spectacle."

During the late 1850s, volcanoes were the least of the problems facing the newcomers to the Northwest wilderness. Isaac Stevens, the governor of the newly-formed Washington Territory, forced treaties and reservations on the Northwest tribes, but gold rushes led to the invasion of the remaining Indian lands by miners and settlers. In 1855-56 open war broke out between the white settlers and the Natives. Led by Chief Kamiakan of the Yakimas, the Klickitats and their allies attacked Seattle and Fort Rains, an Army post in the Columbia Gorge. Then an expedition of two hundred Indians crossed the Klickitat Trail, but the "rebels" were sighted by "Indian Zack," who was hunting at Chelatchie Prairie and who warned the settlers living southwest of the volcano; they fled to safety across the Columbia. Even though the tribes west of Mount St. Helens were too decimated to resist the immigrants, most of the homesteads there were hastily deserted. By 1860, when the second known ascent of the volcano was made, the Indian resistance had waned; the settlers returned, and their thoughts turned to gold.

The August 1860 visit to the summit of Mount St. Helens is thoroughly described in an amusing booklet, *Gold Hunting*

in the Cascade Mountains, written under the pseudonym of Loo-wit Lat-kla. The book mocks the "periodical attacks of 'gold fever' which has frequently prompted small companies and individuals to start out and spend days and weeks in prospecting the large and small sand bars of the Lewis River, and the deep gulches of its tributaries, for the precious deposits which, to their excited imagination, lay hid but a little way beneath the surface." The hordes of prospectors would fail to find the "color" and soon return to their farms and settlements—but would always claim that they were going back to the goldfields "next week."

The book also relates a tale about an earlier attempt to climb Mount St. Helens. Some employees of the Hudson's Bay Company finally found an Indian guide willing to take them up to timberline, but when the party was part way up the Lewis River, a sudden rainstorm drenched them. Half of the men wanted to return home, and the guide refused to proceed further without more blankets. The men who wanted to continue on threatened to shoot the Native guide, but he was protected by the mutineers. Finally, the disgruntled explorers gave up and returned to civilization, forfeiting what could have been a first ascent.

The 1860 climb of the volcano was made by a group of six settlers who headed up the Lewis River to hunt elk, prospect for gold and "rusticate awhile." They followed the Simcoe (Klickitat) Trail up the river past the homesteads at the lush "Cha-la-cha-Prairie," but the men soon bored of prospecting in the Lewis River "diggings." Reasoning that the gold hunting would be better farther up the side-streams, the party found a Klickitat Indian, John Staps, who finally agreed to "pilot" them through the thick undergrowth on Mount St. Helens' steep ridges up to the base of the volcano. After a long, torturous climb, the party found the peak "standing like a hoary-headed giant amongst an army of dwarfs." On a bed of lava called "She-quash-quash," the guide and his companion were appalled by the tourists' irreverent noise and predicted that the Great Spirit would, as always, retaliate with a storm. According to the author: "Greatly rebuked were some of us who had been cursing the way, when these untutored savages told us that they had too much reverence for the Spirit, and were too much awed by this evidence of His mighty power, to laugh and talk foolishly in the sight of Him who had devastated the traditional hunting ground of their fathers." To the chagrin of the infidels, "rain soon began to pour down in torrents."

The author seemed to find religion atop the volcano and "felt as if nothing was easier than to soar from crag to crag and from peak to peak, but the intense cold served to bring us to reason again, and make us feel that we were yet in the flesh." During the descent, the party almost slid into a huge crevasse. Unlike the other cracks in the glacier, this chasm "increased in width as far down as we could see, probably 300 feet, assuming the form of an inverted funnel." When steam rose from the crevasse, the author asked if there could still be "some latent fire, an embryo volcano, struggling into life and activity"; he predicted that "we may yet live to witness another eruption of Mount St. Helens."

The exhausted climbers reached the timberline camp after sunset, and the Indian guides cooked two deer and a huge woodchuck. The guides "predicted a tremendous storm, and admonished us to hurry from the mountain before it came upon us, because the Tie [God] was mad and meant to punish us for our invasion of his domain." The party wanted to go to Spirit Lake next—but changed their minds when "the most terrific rain storm I ever witnessed came down upon our pathway, saturating everything." Snow suddenly covered the peak from timberline to the summit. The adventurers headed home, but their travels were made hazardous by floods.

Upon the climbers' return home, the other pioneers were primarily interested in whether or not any gold had been found, but the Klickitat Indians "were greatly exercised" by the rumors of an ascent of "Loo-wit-lat-kla." When the tribe heard that one of their own had guided the expedition, they were sure that their people would be "punished, if not destroyed" because of the trespass. "Fearing the storm raised round his ears," John Staps, the guide, denied any participation; he "probably saved his bacon by his resolute persistence in asserting a lie; but the Indians still look upon our party with suspicion." The Klickitats were not destroyed, but they were sent to the Yakima Reservation east of their homeland.

Mount St. Helens remained almost "terra incognita" for decades, although a few more people climbed it before the next turn-of-the-century. The crater on the north slope disappeared beneath glaciers sometime between the McBride ascent of 1874 and the 1883 climb by a group which included the first women to reach the summit. The first ascent via the north side was probably made in 1893 by Colonel Plummer's party, whose guide, Leschi, was one of the first Indians to break with tradition and visit the top of the mountain-god.

The Northern Pacific Railroad was completed from Kalama to Tacoma in 1873 and stimulated the development of the region west of Mount St. Helens. Kalama and Centerville (Centralia) boomed in the 1870s, the first store in Woodland opened in 1881, and Kelso was platted in 1884. The town of Toutle was founded in 1876; logging of the watershed followed a decade later, and a logging railroad was built up

▷ Swimmers plunge into the chilly waters of Spirit Lake at the Portland YMCA camp. The YMCA's first summer camp, visible on the south shore, was held in 1909, and a special-use permit was obtained for a permanent campsite in 1911.

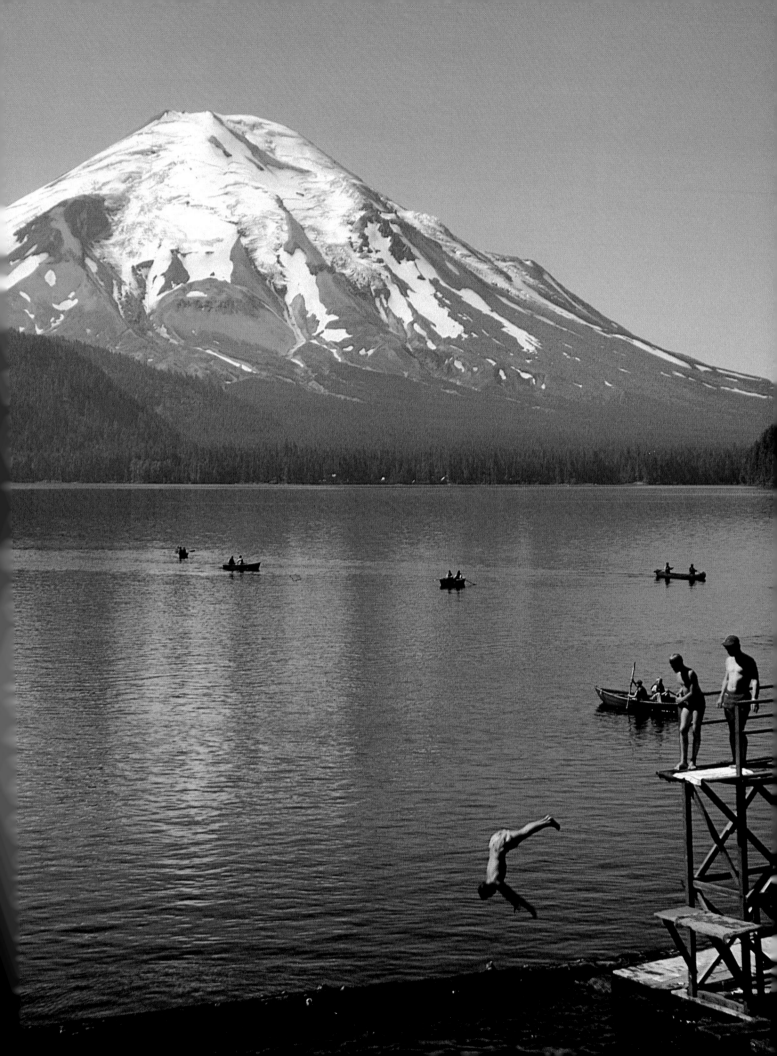

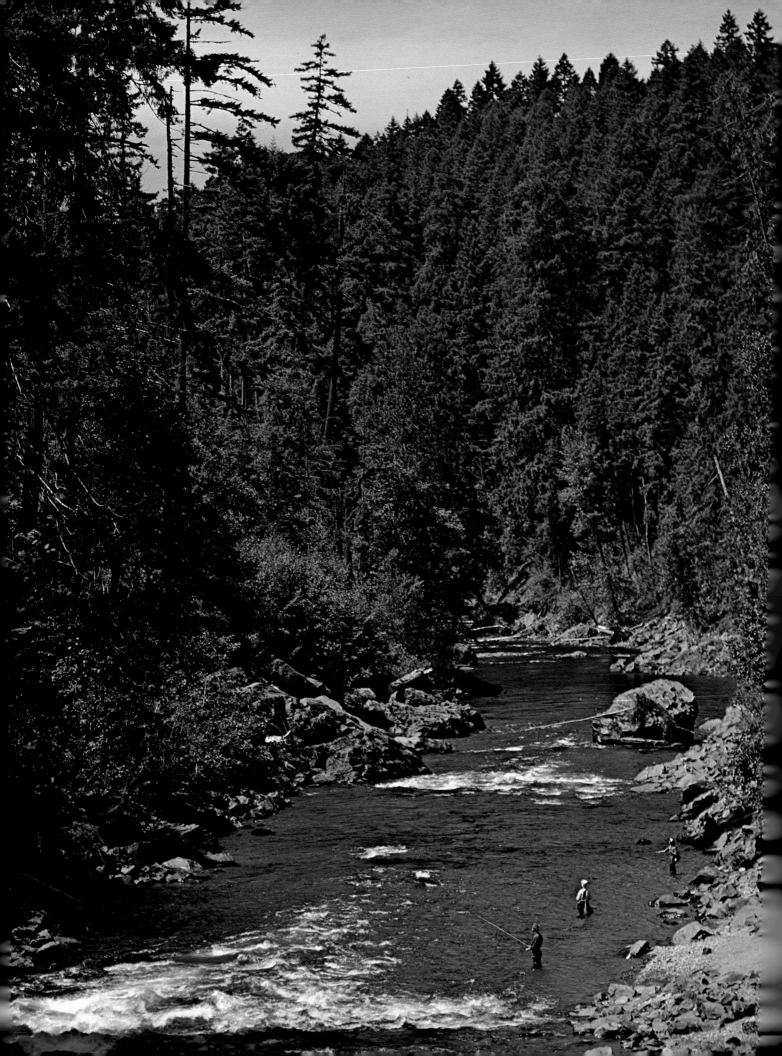

the valley in 1895. In the Lewis River watershed, Yale was founded in 1867, the Speelyai mill opened in 1890, and the company town of Yacolt was established a short time later.

Many visitors came to Mount St. Helens to hunt elk on the partially wooded lava fields above the Lewis River. Ole Peterson, a Cougar pioneer, found the first of the lava tube caves on the volcano's south side while hunting deer in 1895. Ole's Cave soon became a popular tourist attraction—as did Ole.

Development—recreation and otherwise—arrived slowly at Mount St. Helens; the peak was remote from navigable waterways, the rugged canyons surrounding it were nearly impassable, and eruptions were still within recent memory. Robert Lange homesteaded downriver from Spirit Lake in 1879 and built a trading post; Marsh and Hofer were also early settlers in the area. Mining began just north of the volcano in 1891, two years after Washington became a state, and the St. Helens Mining District was established in 1892. Pressure from prospectors led County Commissioner Studebaker to build the first wagon road from Castle Rock to Spirit Lake in 1901. Dr. Henry Coe, who had previously worked at an "Alaska sanatorium for the insane," bought out early mining claims and even sold stock to Teddy Roosevelt. Lange traveled to Germany where he borrowed a quarter million dollars to develop his claims next to Coe's. Barges were used to haul machinery and ore across Spirit Lake. A fire at Lange's mine in 1908, started by the smudge pots miners used to keep flies off their horses, burned the forest on the south side of Mount Margaret. Interest in the mining area fizzled out by 1911, although some gold, silver, copper and other metals have been taken out over the years. Mining claims continued to be filed, primarily to gain ownership of the timber.

Mount St. Helens was first included in a federal forest reserve in 1897 and became part of Columbia National Forest in 1908, during a period of huge forest fires. The U.S. Forest Service built a guard station at Spirit Lake in 1910 and a ranger station in 1913; a fire lookout was later constructed atop the mountain. The Spirit Lake–Trout Lake trail was blazed in the early 1900s, but most of the region's trails were built in the 1930s by the Civilian Conservation Corps (CCC). Four youth camps, beginning with the Portland YMCA camp, were located on the shoreline of Spirit Lake, as were a few private resorts and many private cabins. Public campgrounds were built at the lake in the 1930s. Coe's Dam raised the level of Spirit Lake a couple of feet, and three large power-generating dams were built on the Lewis River just south of the volcano.

Meanwhile, Mount St. Helens remained *almost* quiet. In 1898 the *Seattle Post-Intelligencer* reported that "great volumes of smoke are emitting from its crater"; the local people felt "great consternation" and were "naturally much excited and somewhat alarmed" at first, but the incident was soon forgotten. Five years later, three people caught in a storm near timberline heard a "terrible explosion," followed by "a violent trembling of the earth" and "a hailstone of rocks and dust." The 1903 eruption was "so severe" that the party was "thrown to their knees, rocks were hurled in different directions and the trees swayed to and fro as if in a hurricane." Another minor eruption took place in the winter of 1921. Newlyweds Mr. and Mrs. Claude Crum told the *Kelsonian* that they were in a cabin at Spirit Lake when "it became as dark as night early in the afternoon and there was a terrific electric storm." Three days later, however, they "were making the rounds of their trap line" and found that the mountain's north and northeast slopes "were dark with a fine powder like cinder dust."

Despite these "supernatural" occurrences and the fumaroles and warm spots near The Boot on the north slope, local residents were generally more interested in Sasquatch, alias Bigfoot, than in vulcanism. Indian stories told of huge, ape-like creatures in these woods, but the current Bigfoot legends began in 1924, when a group of hairy giants reputedly attacked six miners on Mount St. Helens. The miners claimed that they shot one of these creatures and it fell into a deep ravine (forever-after known as Ape Canyon). A search party from Kelso and Longview failed to find the Sasquatch's body, but—according to some sources—the miners' cabin had been destroyed by large boulders thrown by the beasts. Huge footprints found around the mountain in the following years caused much excitement—and brought in reporters and tourist dollars—until it was discovered that all of the prints were of the same right foot.

A new road from Castle Rock to the lake was opened in 1939 and was paved in 1946. A paved road to timberline was finished in 1962 to provide access to a planned downhill ski resort, but avalanches made the project impractical.

When Mount St. Helens erupted, local conservationists were working to protect and restore the area around the mountain within a national monument or scenic area administered by the National Park Service.

Ironically, shortly before "Loo-wit" dramatically returned to life, a noted conservationist, pleading for the protection of Washington's "gentler, more vulnerable Southern Cascades," wrote that the Northern Cascades were largely protected by their ruggedness, but around Mount St. Helens, "nature must depend heavily upon man with a sensitivity toward wild lands to come to her defense."

◁ *Salmon and steelhead migrated up the Toutle to Spirit Lake. Summer steelhead were introduced into the river in the 1960s.*

▷ ▷ *Winter snows glisten on the north slopes. Danger of avalanches made plans for a downhill ski area impractical.*

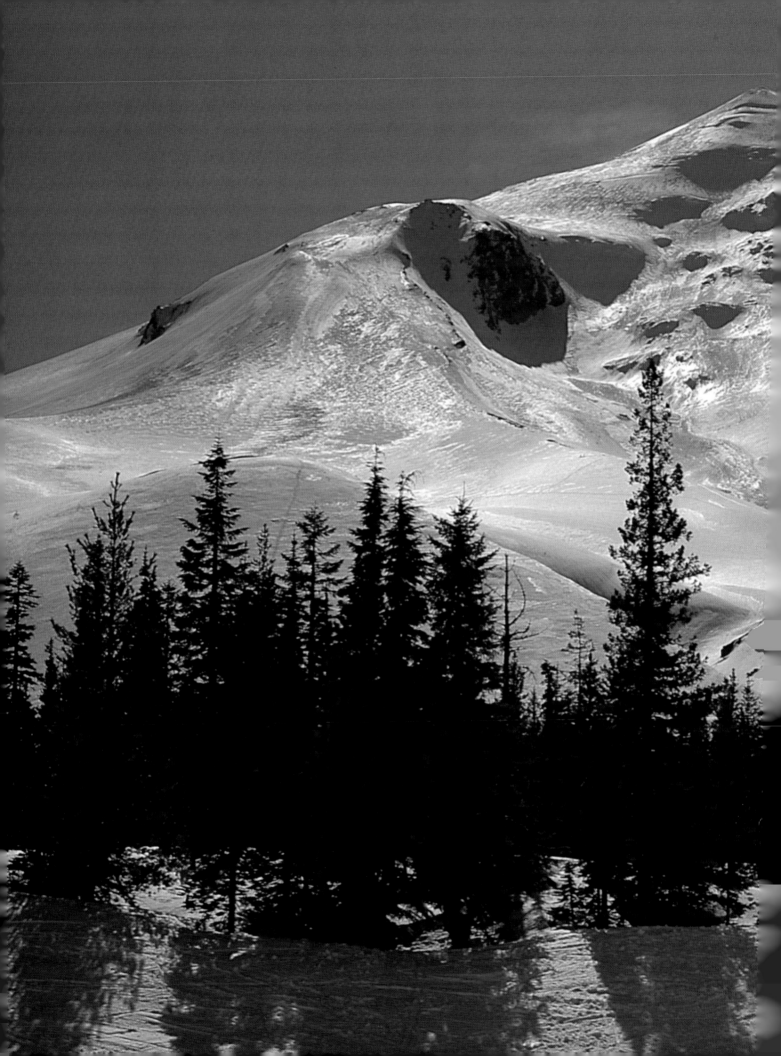

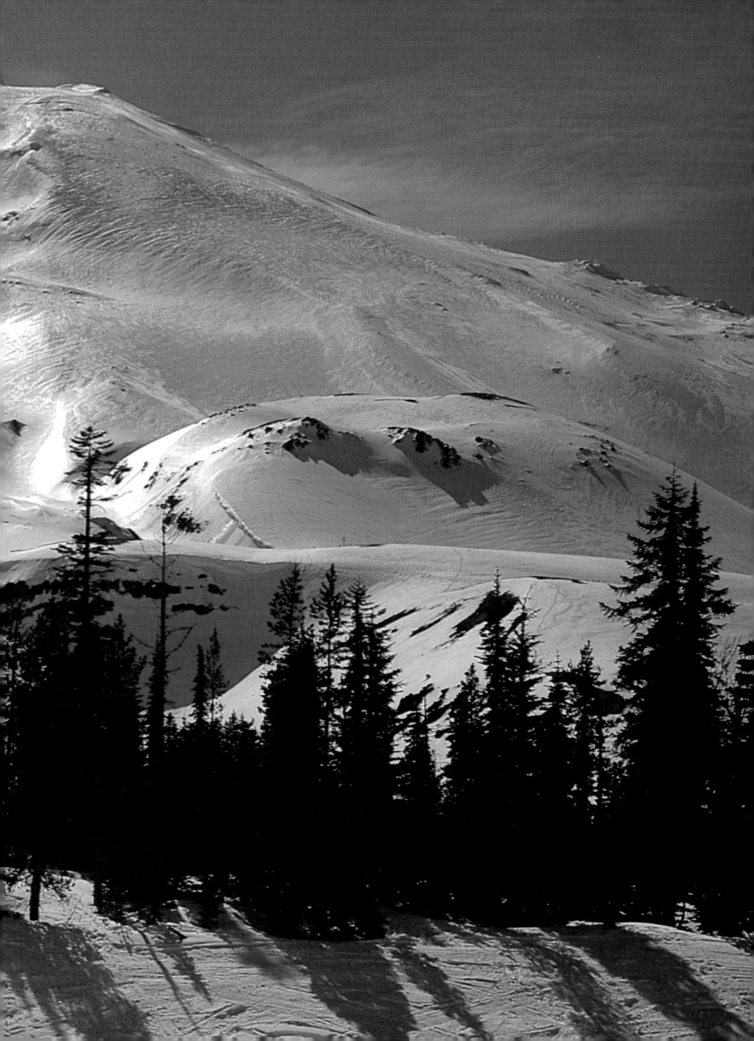

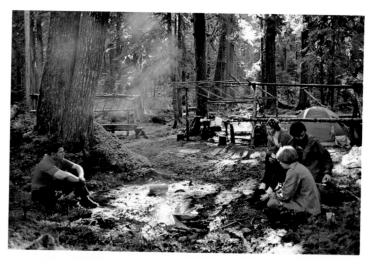

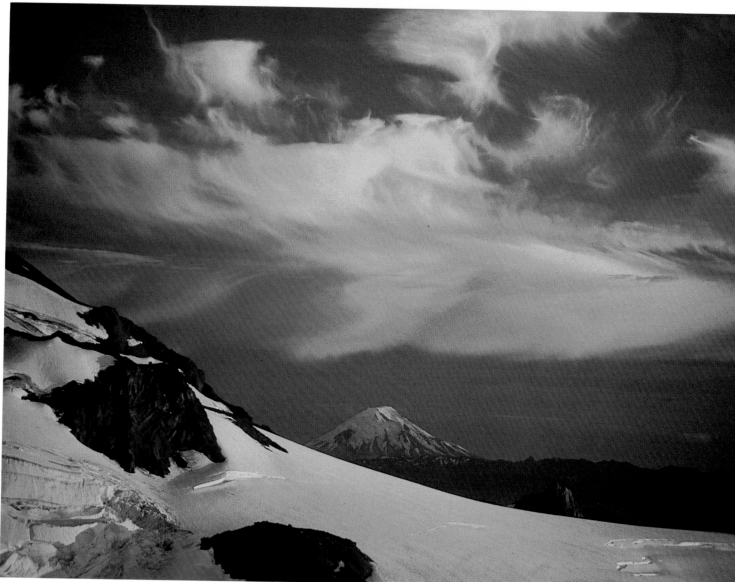

◁ Lt. Kautz observed in 1858 that Mounts St. Helens, Adams, and Hood rise above the clouds, "looking like pyramidal icebergs above the ocean." △ △ The backcountry north of Spirit Lake was a backpackers' paradise featuring small lakes, centuries-old trees, and alpine meadows. △ This view of Mount St. Helens was from Mount Rainier. ▷ ▷ South of the mountain, Yale Lake (shown here), Swift Reservoir, and Lake Merwin provide recreation as well as hydroelectric power.

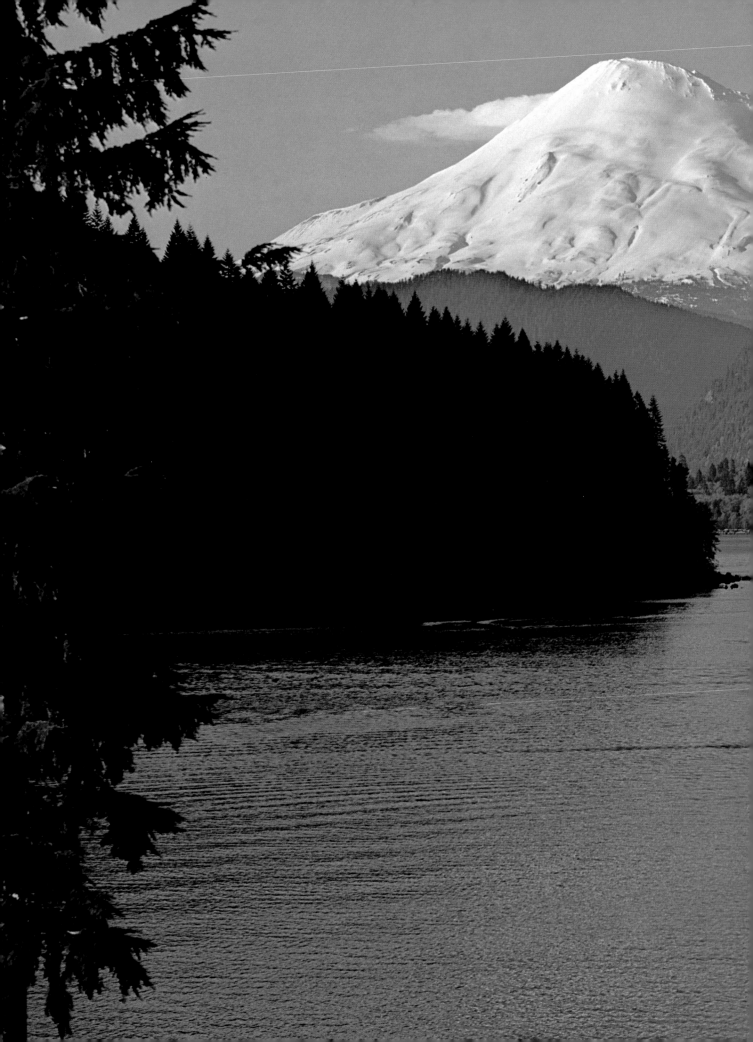

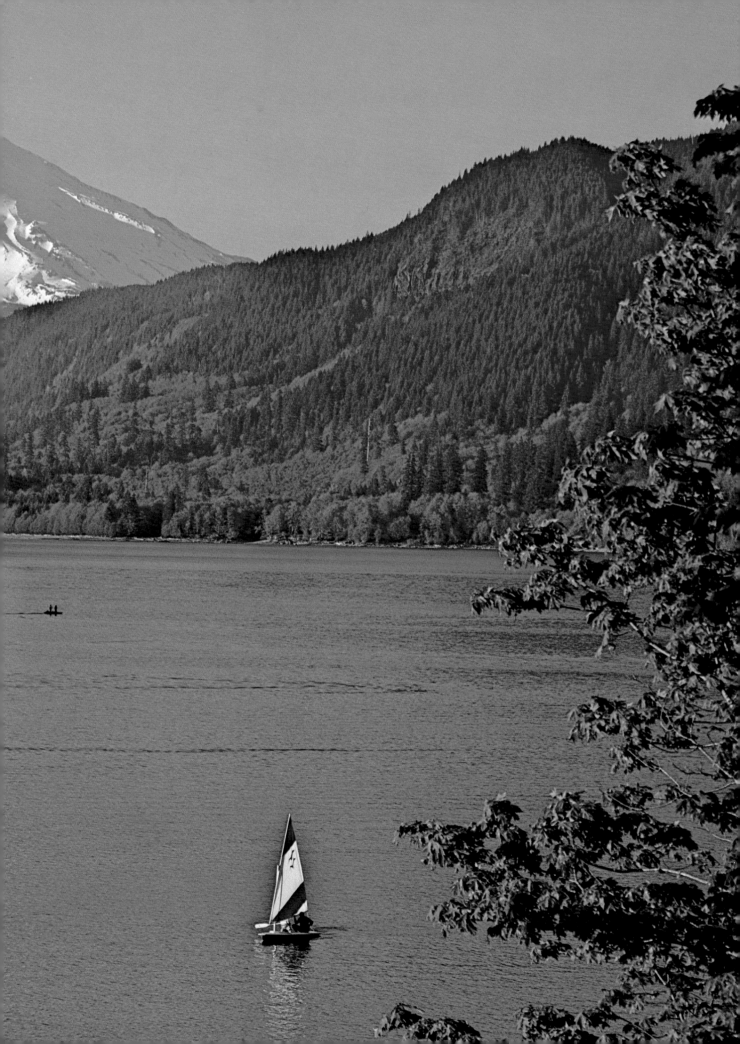

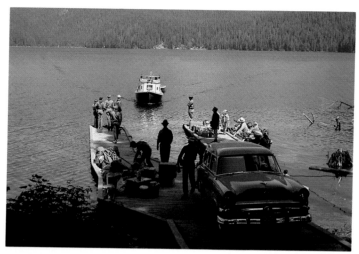

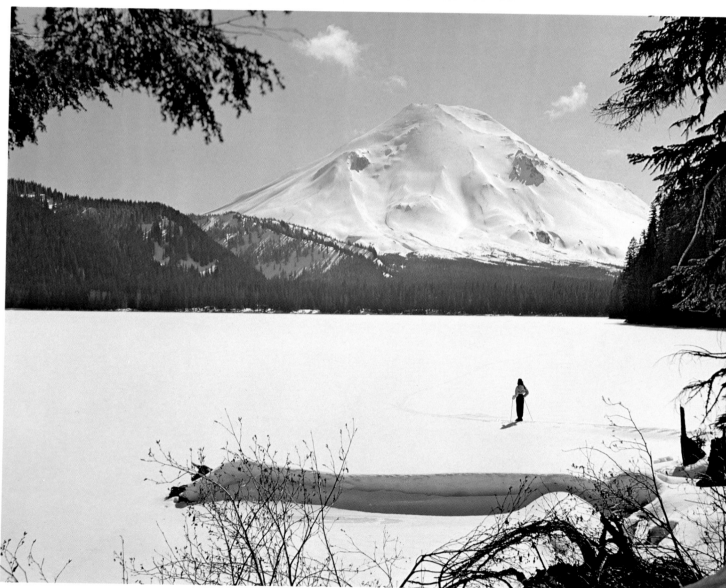

◁ The roar from Harmony Falls attracted hikers and boaters alike as it echoed across Spirit Lake. △ △ In this 1954 photo, Boy Scouts and other vacationers wait on Spirit Lake's south shore dock for the *Tressa,* a former Russian lifeboat put into service in 1946; the boat was still in use in 1980. △ A cross-country skier ventures onto frozen Spirit Lake. ▷ ▷ Ash-laden steam broke through Mount St. Helens' ice crown and opened a 250-foot-wide crater March 27, 1980.

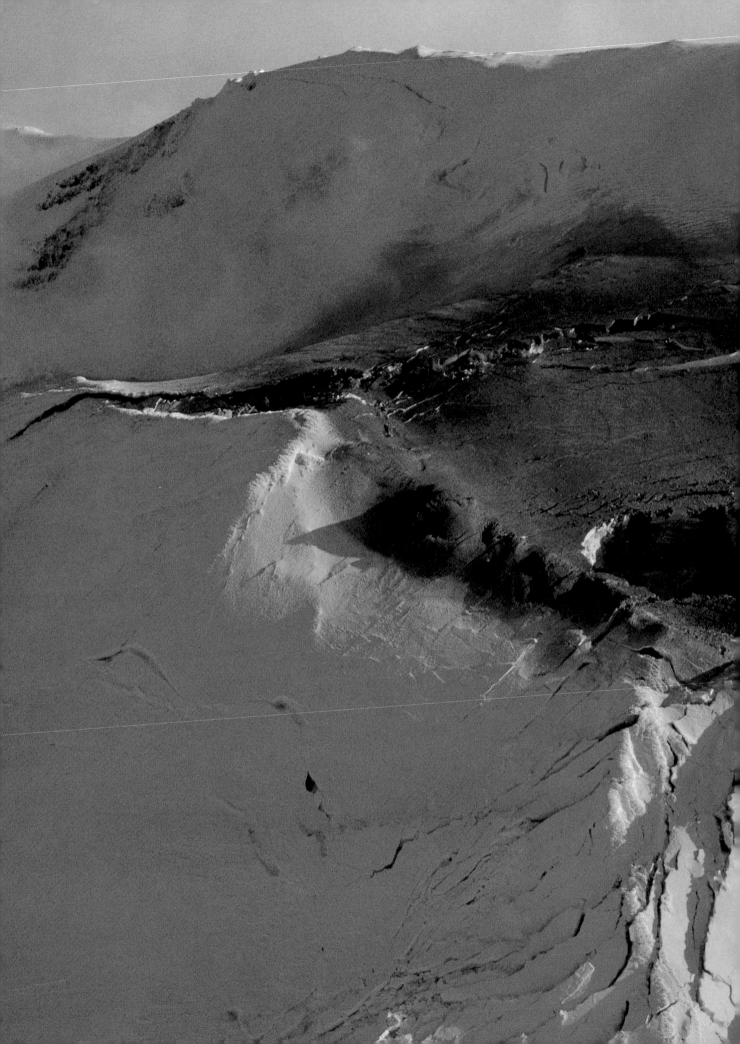

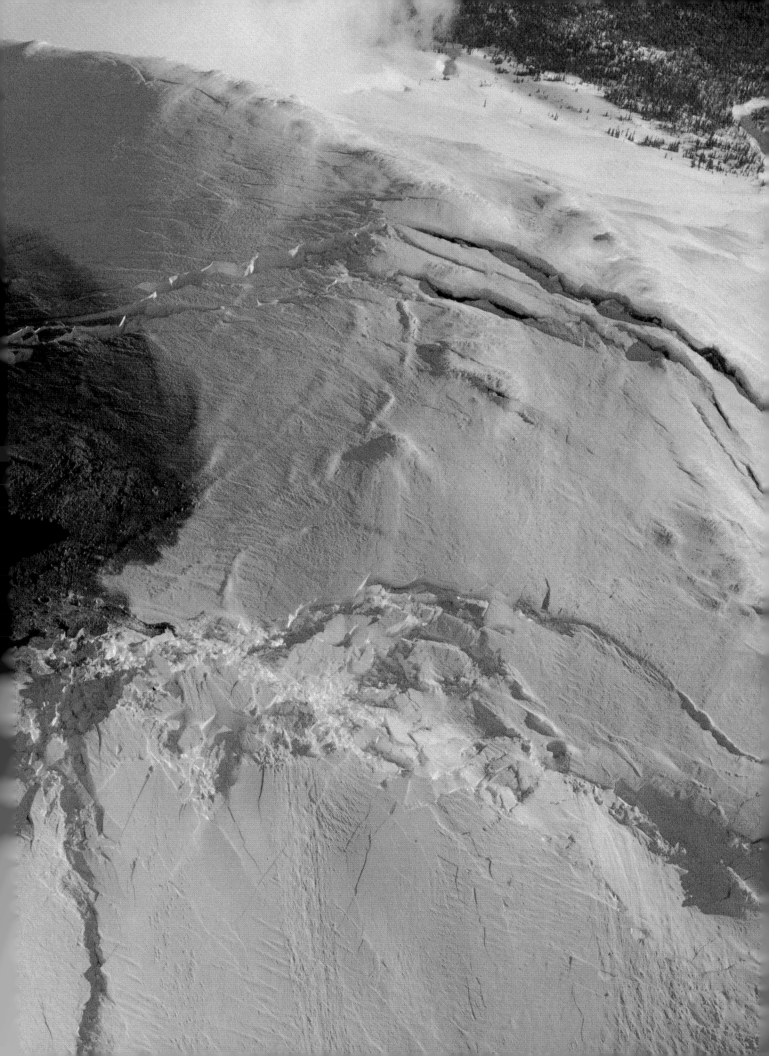

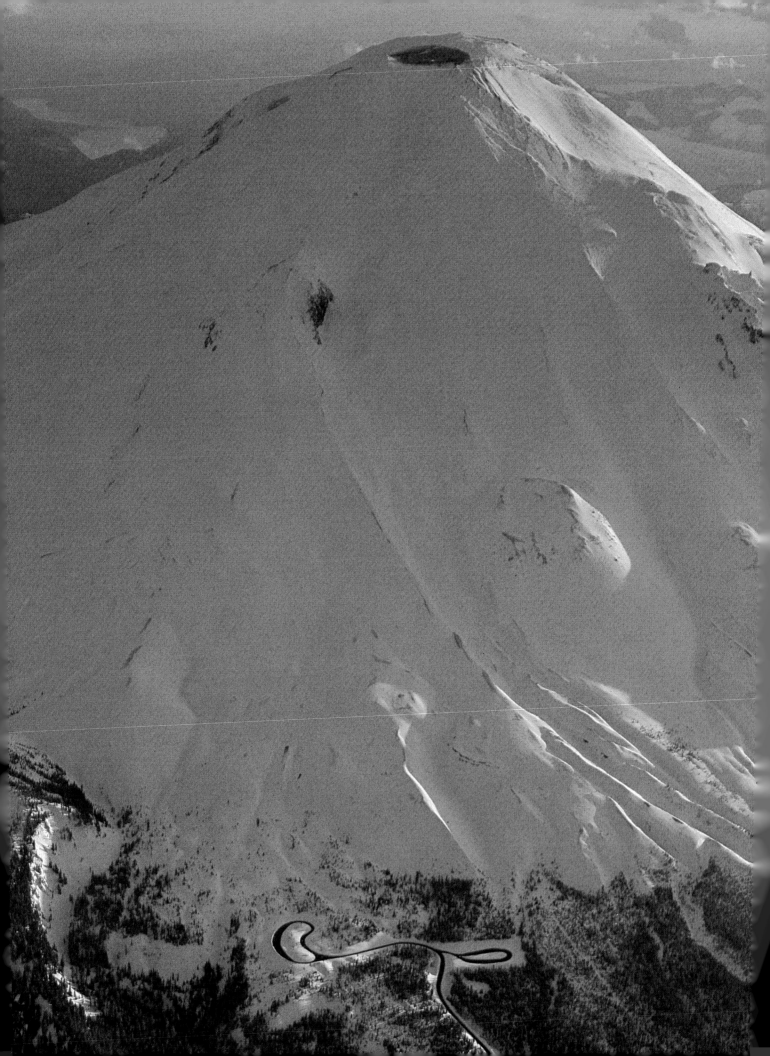

Eruption & Resurrection
by Stuart Warren

On May 18, 1980, pillars of gray smoke flecked with streaks of lightning rumbled out of Mount St. Helens. Glaciers and snow on the summit melted instantly, and huge blocks of ice and bubbling mud hurtled down the northeast flank of the mountain to the rivers and valleys below. This slurry of moving earth swept up trees and animals in its path. Waves of burning wind came next to further scour the landscape. Finally, volcanic ash rained down from the sky, turning day into night.

Almost two decades later, thousands of elk graze islands of greenery in the middle of an ash-strewn moonscape, and wildflowers add a palette of color that had not existed in the dense forest prior to the eruption. The renewal of life in the shadow of the mountain has been surprisingly rapid, diverse, and extensive—so much so that there are moments here that feel as though one is standing on the shore of creation.

In fact, the ecosystem of Mount St. Helens has rebounded with such vigor from the eruption that it is actually possible to imagine a time when most of the scars left behind by volcanic activity will be healed. If the words of helicopter pilot Ray Pleasant are any indication, such a notion would have been inconceivable immediately after the volcano's big blow:

It was like heaven to hell in the blink of an eye. I was cruising over one hundred square miles of toppled trees that had been a forest a short time ago. With everything gone and all the smoke, I kept losing my bearings. Even a decade of experience flying here for a timber company can't prepare you for lakes and ridgelines being in places where they hadn't been before.

The search for reference points was not just confined to the geography of the blast zone. Just ask tens of thousands of eastern Washingtonians whose cars were immobilized by Mount St. Helens ash clogging their engines. Even if their vehicles had been able to move, noontime road conditions approached near-zero visibility. On the other side of the volcano, Kelso and Longview, thirty and fifty-five miles downstream respectively, watched houses, bridges, and logs float by on the mud-filled Cowlitz River.

When more than half a mile in elevation exploded off the summit of Mount St. Helens, no longer were disastrous volcanoes something that only happened in far-off countries with unpronounceable names. Suddenly, nature became a force to be reckoned with for millions of people in a country unused to earth changes on so massive a scale. To more fully comprehend the meaning of "massive" in a volcanic context, consider the following:

- The debris avalanche rocketed down the mountain at speeds of 150 to 180 miles an hour, the largest landslide in recorded history. Derivative mudflows damaged or destroyed twenty-seven bridges, 185 miles of roads, and more than two hundred homes. The mud and ash also blocked major shipping channels on the Columbia River near its confluence with the Cowlitz for months.

- The lateral blast of white-hot gases, pieces of pulverized rock, and organic material were collectively thrust out at speeds of hundreds of miles an hour and blew down enough timber to build three hundred thousand two-bedroom homes.

- The vertical ash eruption rose nearly sixteen miles into the atmosphere, darkening eastern Washington orchard country and clouding parts of Montana nine hundred miles away (the most distant point where there was measurable ashfall). It eventually circled the globe and deposited enough material to bury a football field to a depth of 150 miles.

- Human fatalities totaled thirty-six people known dead, twenty-one missing.

- Estimated game fatalities numbered around five thousand black-tailed deer, fifteen hundred Roosevelt elk, two hundred black bear, fifteen mountain goats, and millions of small game, birds, and fish.

- Most of the previously cited damage and fatality figures occurred within minutes after the mountain blew its top, encompassing a fan-shaped swath of destruction fifteen miles long and eight miles wide.

◁ *Shortly after the eruption that took place March 27, 1980 (which shot ash-laden steam some seven thousand feet into the air), the plowed road to Spirit Lake and the Timberline Viewpoint was closed by government officials.*

The foregoing tale of the tape elucidates why May 18, 1980, is seared into the region's collective psyche and raises some very troubling questions. In light of the volcanic events before and after that fateful day in May, what are the chances another major eruption will occur again within our lifetimes? If so, how soon? While the majority of scientists are noncommittal on these subjects, the previous major eruption cycle ending in 1857 lasted several decades, indicating that more activity is quite likely. However, almost two dozen eruptions have taken place between May 18, 1980, and the end of 1996, perhaps reducing the pressure build-up necessary for another catastrophic event.

In any case, further insight into the future of the most active volcano in U.S. history may be gained by looking at the internal workings of Mount St. Helens. Like all Cascade volcanoes, St. Helens is a product of the collision of ocean plates and continent. The oceanic plate is heavier than the North American plate so it tends to move beneath its continental counterpart and thus is nearer to the 2400°F temperatures of the earth's mantle. Tremendous heat is also generated by the high-pressure interface of the plates so that their edges melt into molten rock. This molten rock or magma then rises through crack systems in the earth's crust, melting the rock around it to form magma chambers. In an active volcano, these reservoirs of eruptive power can take shape several miles below the surface of the earth. The heat that melts the rock releases hot gases whose convection adds to upward pressure pushing magma up and out of the mountain (where it is called lava).

In the case of the recent Mount St. Helens eruptions, however, lava flows were not the problem, for reasons that will be explained shortly. For several weeks leading up to May 18, a four-hundred-foot-high bulge was created by rising magma. It grew larger and more unstable with each passing day until succumbing to explosive forces within. The ensuing massive eruption dramatically broke a three-week lull in the quakes and eruptions that had been shaking the mountain since late March.

Pressure had been allowed to build during this respite until the bulge exploded like an unsecured cork capping a bottle of vigorously shaken champagne. The magma that had been acting as the internal piston in the process contained a large amount of silica whose viscosity inhibited the flow of molten lava down the mountain's slopes. It also contained a lot of water that flashed to steam. Thus, it was the heat released when the bulge exploded, rather than lava flowing out upon the land, that precipitated most of the upheavals here.

History's largest landslide and Mount St. Helens' lateral blast notwithstanding, the eruption is still considered small by world standards. The scientific community's assessment is based upon the amount of molten rock ejected as pumice and ash from a volcano. Considering that most of Mount St. Helens' "big guns" were aimed at the ground where they could do the most harm, such a designation is especially ironic. In any case, this event sent volcanologists back to read the geologic record left by past volcanic landscapes to see if Mount St. Helens–style phenomena were rare or just overlooked by traditional volcanology.

Volcanologists were not alone in experiencing a paradigm shift regarding eruption-related damage. Before Mount St. Helens, the dominant image of volcanic destruction in the public mind was black lava oozing down a mountainside, entombing everything in its path. By contrast, one of the primary agents of apocalypse here in 1980 was the superheated tornado that burst forth from the mountain's flank to level a two hundred-square-mile forest in a few minutes.

Just as the explosions and earth movements of May 18 were unique and unforeseen, the pace and patterns of the ensuing recovery from what was initially regarded as total devastation have also defied expectations. Thanks to a late spring snowpack that protected certain plants and trees from the blast, as well as terra firma doing the same for underground hibernators and burrowing rodents, beachheads of ecological development existed from the outset to expedite the rebuilding process. Thus, the dance of life in eruption aftermath was not solely choreographed by colonizers from the outside as is often the case in the wake of cataclysmic earth changes. Survivors helped jump-start the recovery by creating ready-made niches for an influx of opportunistic life forms.

The complexities of the interaction between survivors and colonizers, and the diversity within the surrounding environment, have resulted in a landscape that is not healing uniformly. Recovery in the blast zone near the mountain, for instance, might be a very different affair than it is on a mudflow far from the crater of Mount St. Helens. Depending on distance and direction relative to Mount St. Helens, vulnerable environments here sustained damage from flood, fire, or moving earth in varying extents and intensities. Ash falls were another determining factor in the character of post-eruption landscapes. Faced with these and other variables, biologists have demurred at making generalizations about the pace and sequence of recovery. Chance plays a big role in what is green and what is gray here, and textbook notions of orderly biological succession quickly go up in smoke.

▷ *The March 30 eruption hurled huge blocks of ice (visible in the photo) into the air. Earthquakes measuring up to 4.9* *on the Richter scale continued to crack the summit. On March 30 alone, seventy-nine earthquakes were recorded.*

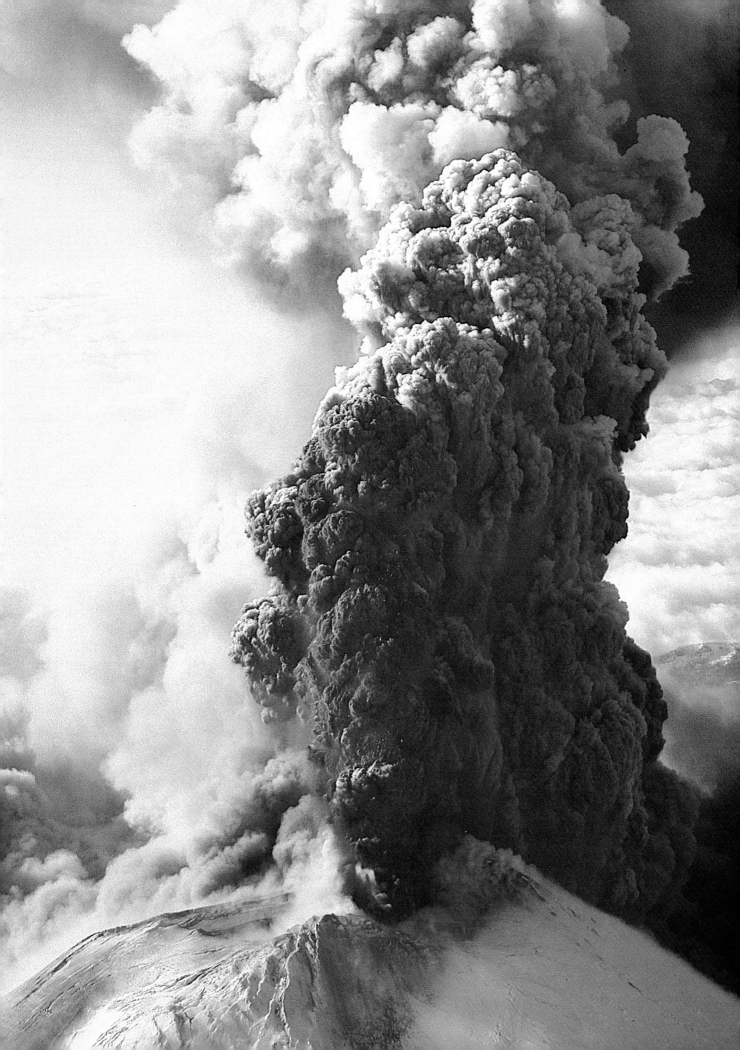

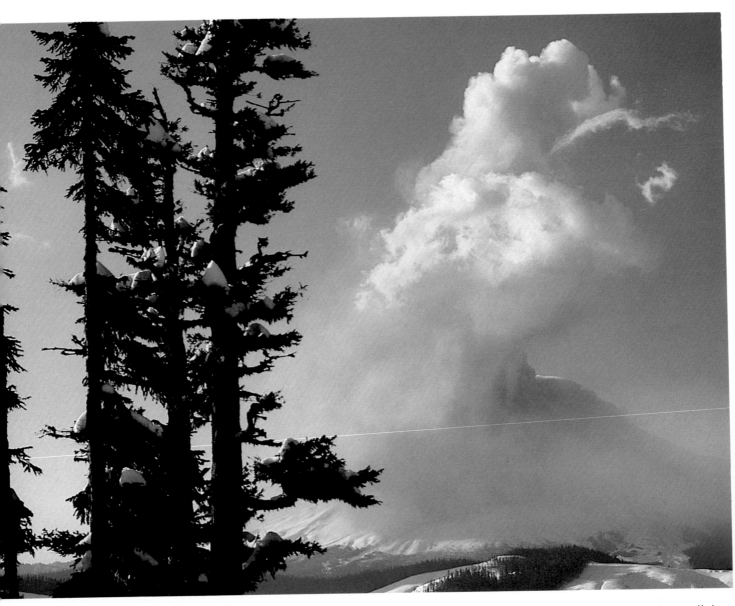

△ A small steam eruption obscures the features of Mount St. Helens on April 4. Harmonic tremors, probably indicating the movement of magma beneath the volcano began April 1 and continued on an infrequent basis. Such tremors are being studied by scientists in an attempt to learn all they can so they may be able to predict future eruptions. Steam eruptions such as this one, as well as smaller ash eruptions, took place numerous times before the "big one" of May 18.

In attempting to predict how future growth may fare in post-eruption landscapes, scientists must consider a multitude of factors both before and after May 18, 1980. What was the depth of the snow cover before the eruption? Were the ash deposits that mantled a hillside after the eruption thick enough to inhibit the original soil layer and roots from being exposed by erosion? Were plants growing on a south-facing slope where they would tend to catch the full force of the blast (as well as the wilting heat of the summer sun in the treeless aftermath of the eruption) or on the better-protected north-facing slopes? How close to water and a seed supply is a particular locale?

While questions about ecosystems emerging in the shadow of Mount St. Helens abound, there is no doubt that a leading hero in this resurrection saga was the lowly pocket gopher. After eating bulbs and roots in the safety of an earthen bunker, this critter would burrow about, enriching the ash-laden soil in the process. The digging activity of gophers along with such subterranean counterparts as mice, weasels, and voles would bring to the surface spores of fungi and organic soil from beneath the sterile growth medium of newly fallen ash, making it easier for plants to absorb nutrients. Gopher mounds served as fertilizer plots where windborne seeds would alight to eventually germinate pioneer plants like lupine and fireweed.

Elk coming in to graze new growth also helped create islands of fecundity in the ash by grinding depressions deep enough to reach the soil, often depositing potential compost in the process. During those first crucial months after the eruption, more help came in the form of spring rains that eroded away layers of nutrient-poor volcanic grit.

In like measure, tree planters working land leased by the government to Weyerhaeuser Lumber Company, penetrated the sterile ash layer by using power augers to reach the soil below. Some of the saplings planted after the eruption were able to exceed fifty feet in height in the decade to follow. These sites were in the blast zone but were not part of the land contained in the Mount St. Helens National Monument set up in 1982, wherein the land is mostly left to regenerate naturally. Little by little, the rotten-egg odor of growth-inhibiting, highly concentrated sulfur, present in newly spewed volcanic material, gave way to the aroma of chlorophyll. Insects came to feed on the emerging plant growth, followed by birds. Droppings from these birds were able to provide fertilizer and seeds over a wide-ranging area.

Other survivors that paved the way for a regenerated ecosystem in the immediate aftermath of the eruption included plant parts still living in exposed root wads of downed trees, as well as aquatic life that had been protected by iced-over waters in lakes. Then, too, there were spring plants still underneath the ground during the eruption. Just

days after the volcano's big blow, fireweed sprouts were observed popping up here and a few weeks hence, pearly everlasting, thistle, and blackberry vines had penetrated through a foot of ash in some locations.

Human survival was aided by several factors: road closures and resident evacuations—and the fact that the eruption took place on a Sunday rather than on a workday.

Several years after May 18, 1980, 90 percent of the plant species and almost all mammals indigenous to the area were observed here, but the eruption had rearranged population and geographical distribution. Despite the volcano-related loss of fifteen hundred elk, for example, by the 1990s, the population had increased threefold from pre-eruption levels. This is attributed to a reduction in predators, an increase in food due to fallen trees that cleared the way for browse, and hunting restrictions on the avalanche debris flow.

Another dramatic turnaround was seen in the riparian environment of Spirit Lake where tons of volcanic debris, tens of thousands of logs, and superheated soils had created a stinking, oxygen-depleted, bacteria-filled cauldron inhospitable to life. In five years, the microbial activity had subsided enough that scientists deemed the lake waters were "back to normal." Two of the most important factors were the addition of huge amounts of fresh water by rain and melting snow, and the stirring action of wind and waves that added oxygen.

By the late 1980s, insect larvae, algae, snails, and frogs graced the waterway whose depths were becoming progressively clearer with each passing year—so much so that officials at the Mount St. Helens National Monument opined that Spirit Lake was capable of supporting salmon and steelhead if there was a way for them to get there. Since the 110,000-acre monument was set up to observe how Mother Nature rebuilds an ecosystem, scientists chose not to stock Spirit Lake. In 1992, however, the sighting by underwater cameras of a sculpin (probably offspring from a feeder stream) swimming amid fallen logs in the murky shallows lent credence to assertions of fish-friendliness. Two rainbow trout caught by scientists the next year left little doubt that life is returning to Spirit Lake.

The shores of Spirit Lake now support an impressive wildflower community with pastel-hued pioneer plants breaking up the grays and browns of the post-eruption landscape. Particularly striking is the colony of lupine that blankets the pumice blocks near the lake. From a single flower discovered in 1983, lupine was able to flourish here because of its ability to extract nitrogen from the atmosphere, a prerequisite on nitrogen-poor pumice. With chain-like blossoms enabling it to trap blowing seeds and a tendency in death to leave a rich mulch, lupine is breaking ground for the forest of the future.

Alden Jones, former chief engineer for Weyerhaeuser, expects that we will see stunted alder and willow growing up near Spirit Lake several decades into the twenty-first century, followed by young conifer stands shortly thereafter. During this time, at least superficially, the complex of thickets and meadows that will develop here might have the scraggly appearance of the boreal forests of Interior Alaska. But in perhaps two hundred years, the soils will have a chance to develop sufficiently to sustain the lush conifers that proliferated north of the volcano before May 18, 1980. On that day, a tidal wave unleashed by volcanic debris hitting the lake wiped out miles of old growth on slopes five hundred to seven hundred feet above its shoreline, ending one ecosystem and beginning another.

Big changes have occurred in the human environment here as well. Let's begin with the visitor experience on the west side of the mountain, the most commonly seen face of "the new Mount St. Helens." Instead of reveling in the snow-capped symmetry that Lewis and Clark's journals described as "the most perfect aspect of its kind in nature," modern travelers here gaze upon a gap-toothed open volcano crater and below it, the raw beauty of one of the youngest ecosystems on earth.

The changes wrought by this landscape's centerpiece are given eloquent voice in five visitor centers encountered on State Route 504, the Spirit Lake Memorial Highway constructed from 1992-1997. The exhibits, multimedia presentations, and other interpretive programs within the Mount St. Helens National Monument help the visitor more fully comprehend the implications of what has transpired here in an eyeblink of geologic time. The most surprising recurring message is that volcanoes contribute much more than damage to the land. They provide materials such as calcium, phosphorous, sulfur, and potassium needed to create and sustain life. In fact, volcanic soils over time have proven to be some of the most fertile in the world. This may have been a contributing factor to the record crop yields recorded in certain sectors of the Washington orchard country in the decade following the 1980 eruptions. Some scientists even believe that the combination of gases released by volcanoes parallels the composition of atmospheres that incubated the first organisms on the planet.

Such assurances would have meant little to people who lived within fifty miles of the volcano after May 18, 1980. In the face of a tragedy that left two hundred families homeless and caused massive economic dislocation, it is hard to have the perspective of the ages. For many Lewis and Cowlitz Counties residents, losing the serene countenance of Mount St. Helens was like erasing a chapter from their lives. This was their playground, their backyard, the place for camping and fishing trips that made it into family scrapbooks. Their feeling for the place was perhaps best expressed by the person most identified in the public mind with the volcano, Spirit Lake Lodge owner Harry Truman. In response to questions about why he refused to leave, he shot back, "Leave? I can't leave. Mount St. Helens is part of Harry Truman, and Harry Truman is part of Mount St. Helens."

While thoughts of the volcano burying the popular lodge owner or a family cabin does not lend itself to scientific detachment, people who live in the shadow of the mountain have still been able to get on with their lives. This is evident from the response to two of the most severe environmental dislocations caused by the Mount St. Helens eruption. First, the people of Kelso, Washington, pumped tons of ash that had blocked shipping lanes on the Cowlitz River up onto a landfill to create a very special recreation facility. After planting grass on top of the ash-laden soil, this rainy town had the driest golf course west of the Cascades—thanks to porous volcanic material that allows water to percolate down through it.

In like measure, the same Toutle River that was transformed into a morass of bubbling mud by heat from the eruption has come back as a leading steelhead stream, thanks in part to local initiative. After the riverbanks had been denuded by mudflows, they were replanted with red alder and cottonwood, trees that would shade streams (important for the cold-water-loving steelhead) and hold soil in place to inhibit siltation. This action complemented some good effects of the mudflow. After the debris in the river water had filtered out, amounts of coarse rock in the Toutle riverbed had increased, making it easier for spawning steelhead to wedge themselves into a stationary position, thus expediting the mating process. The spawning habitat was also improved by an increase in zooplankton generated by the temporary rise in water temperature in the aftermath of the eruption. Today, steelhead fishing is actually better than it had been prior to the eruption.

The eruption and renewal of Mount St. Helens has provided an exceptional opportunity to observe geologic and biological processes that usually happen over millenia. From this, our understanding of how nature works has increased dramatically. Hundreds of ongoing research projects are using the model of Mount St. Helens to learn lessons that apply to resource management, predicting volcanic eruptions, and ecosystem evolution. In addition, millions of visitors return from Mount St. Helens with realizations that resonate in their daily lives—the resiliency of the life force, the relatedness of all things in nature, and the fact that there is nothing permanent except change. This experience imparts a sense of our place in the universe, giving us the knowledge and inspiration to become better citizens of the planet.

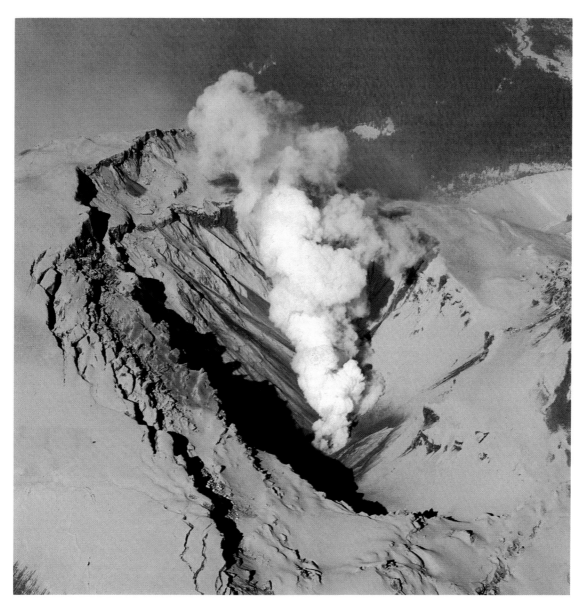

△ Though the crater occasionally vented steam, it was relatively calm from April 23 to May 6. During this time, Harry Truman, the Spirit Lake Lodge owner who refused to leave, grabbed more headlines than the blister that formed on the mountain's north side. The explosion of this bulge, along with earthquakes and ash plumes, signaled the beginning of the May 18 eruption.

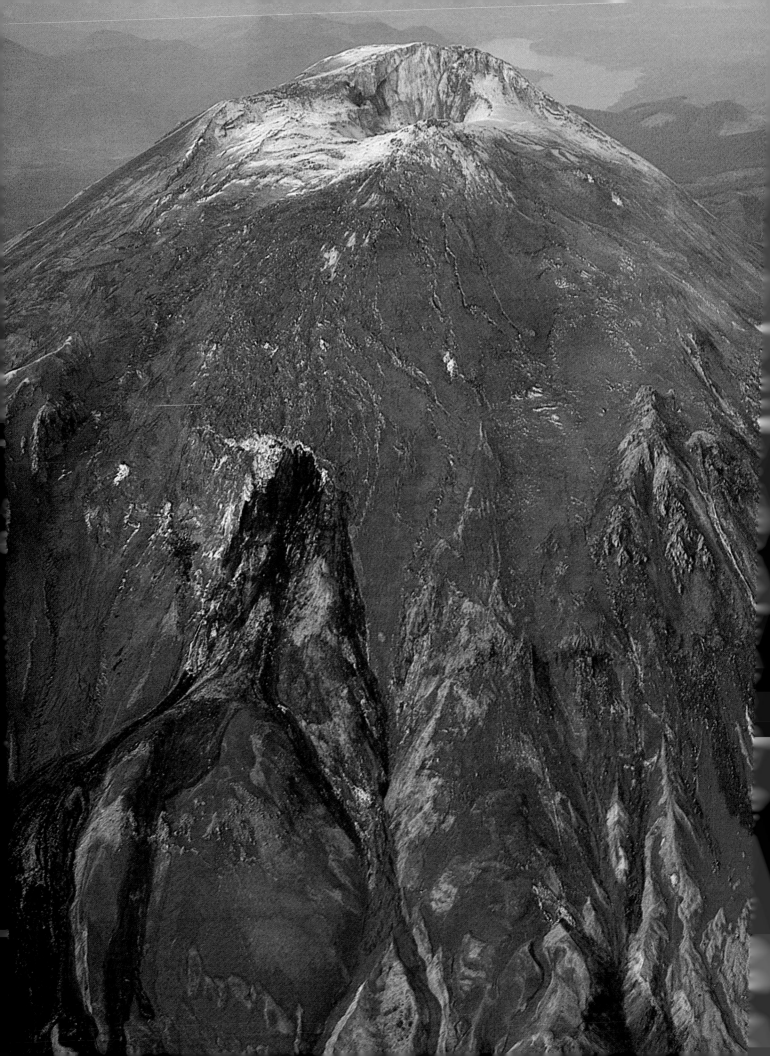

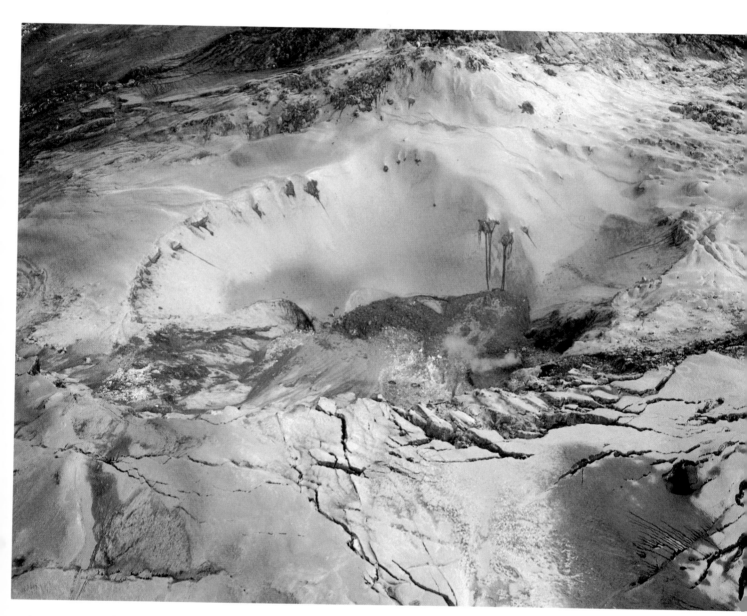

◁ At approximately 8:00 A.M. on May 18, 1980, avalanches and ice flows were observed on the swollen, fractured north face from a plane thirteen hundred feet above the summit.

△ This photograph, which was taken around 8:10 A.M., clearly shows water seeping from the crater's north wall and a small lake that was starting to form inside the crater.

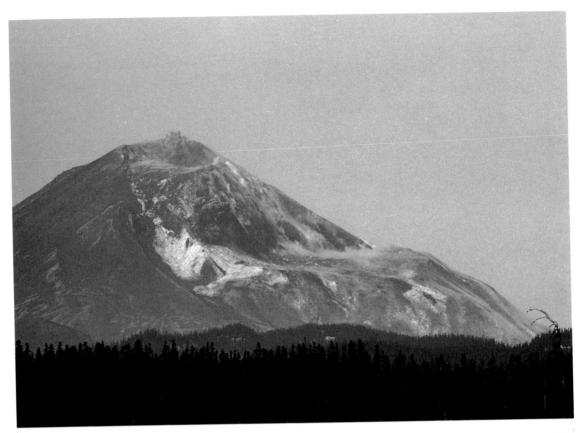

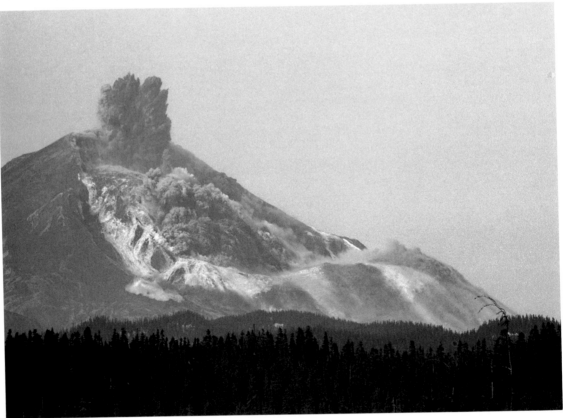

△ These four photos, taken seconds apart, were shot from Bear Meadows, twelve miles northeast of the mountain, and recorded the explosion that blew over half a cubic mile of Mount St. Helens into the air. The initial landslide was still moving down the mountain when a vertical eruption

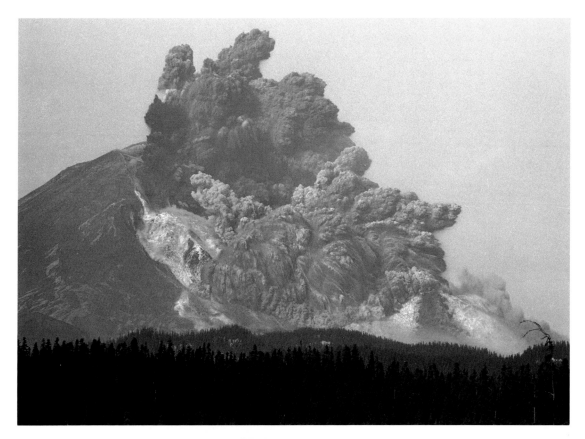

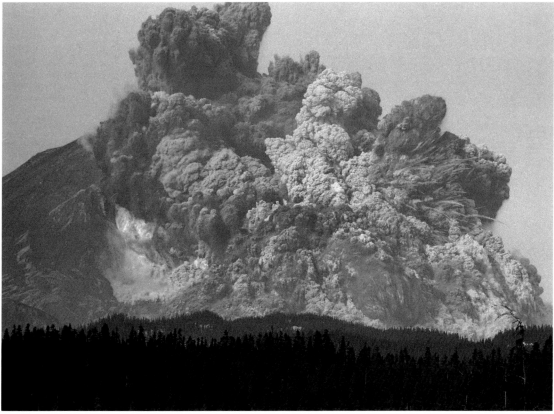

burst from the summit and a lateral blast blew out what remained of the north face. The lateral blast overtook the landslide, burying everything within four miles to the north. Superheated ash clouds and shock waves caused further devastation up to seventeen miles from the volcano.

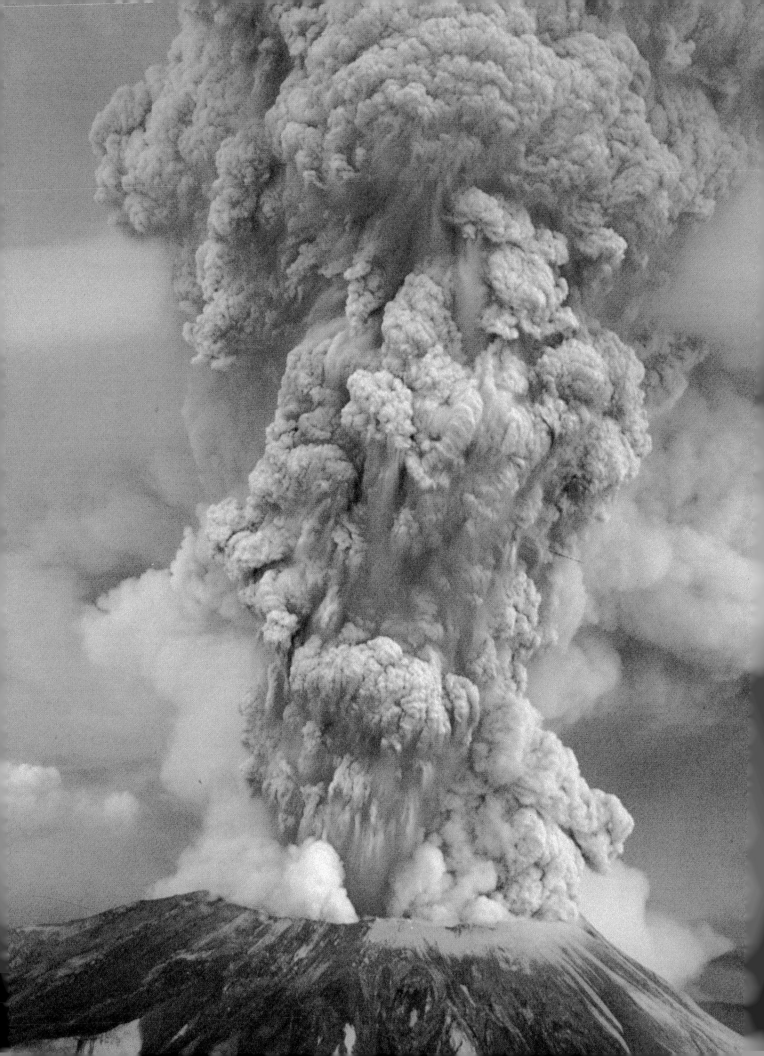

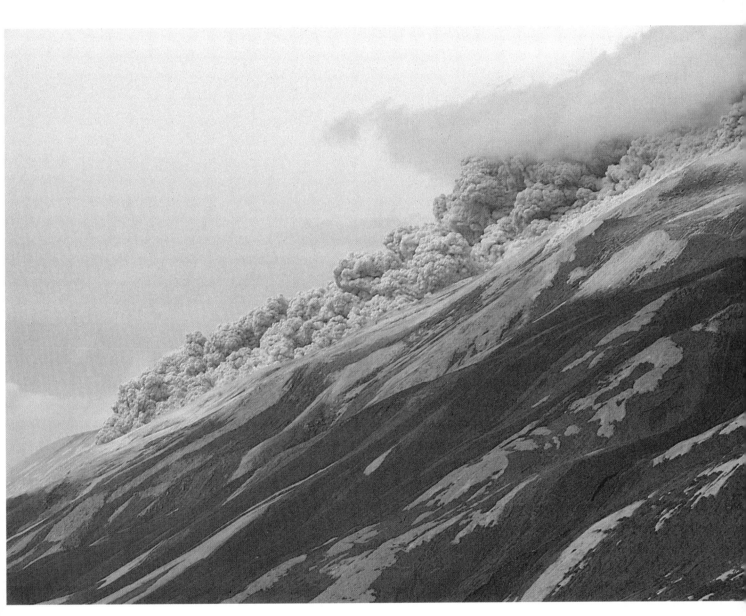

◁ Taken at 10:00 A.M. on May 18, 1980, this photo shows the huge ash cloud that shot up during the eruption's early stage.
△ Pyroclastic flows during the day reached temperatures over 500°F and speeds up to two hundred miles per hour.
▷ ▷ The vertical eruption blew steam and ash some sixty thousand feet into the air and continued throughout the day.

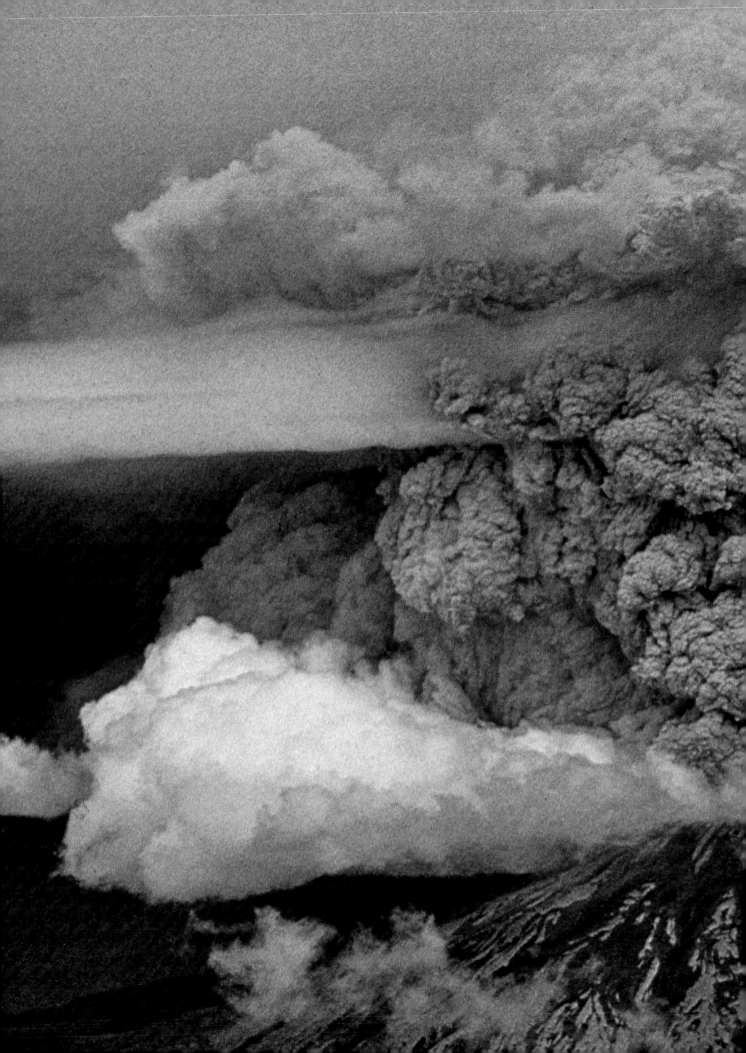

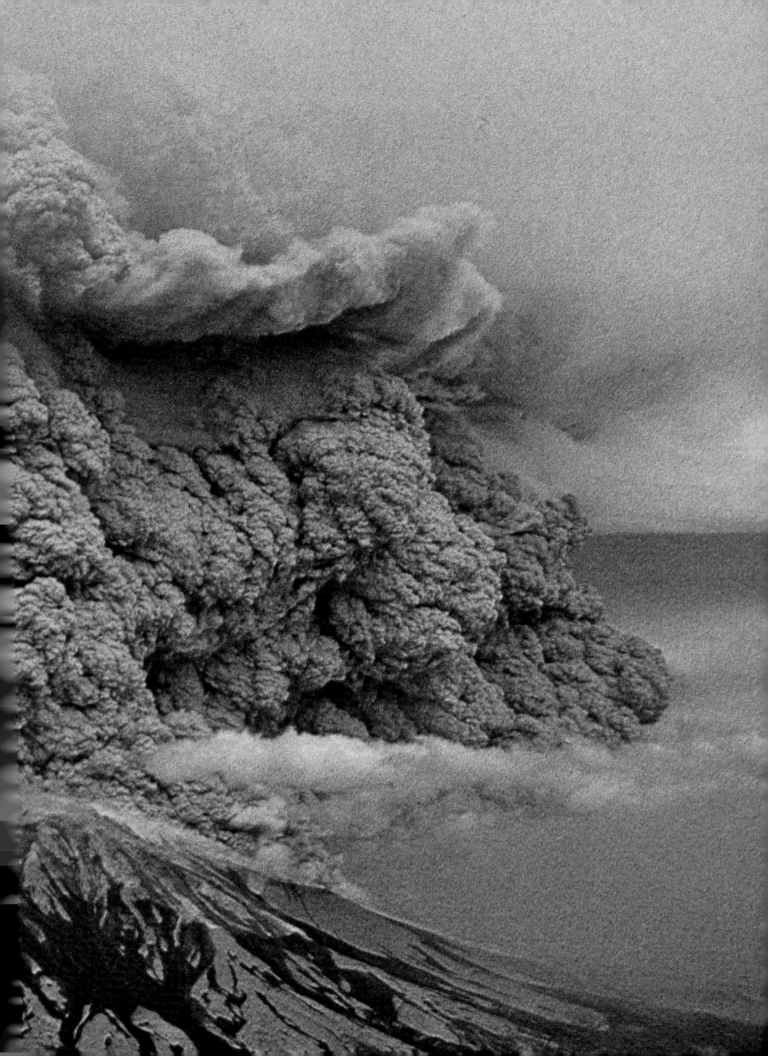

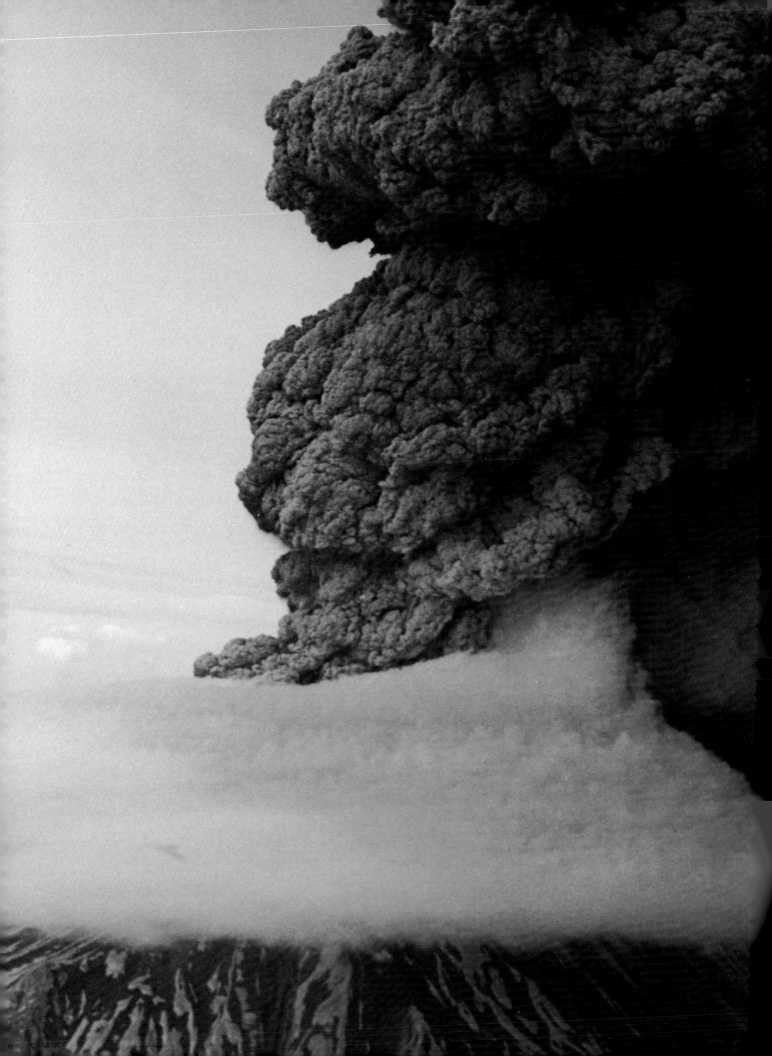

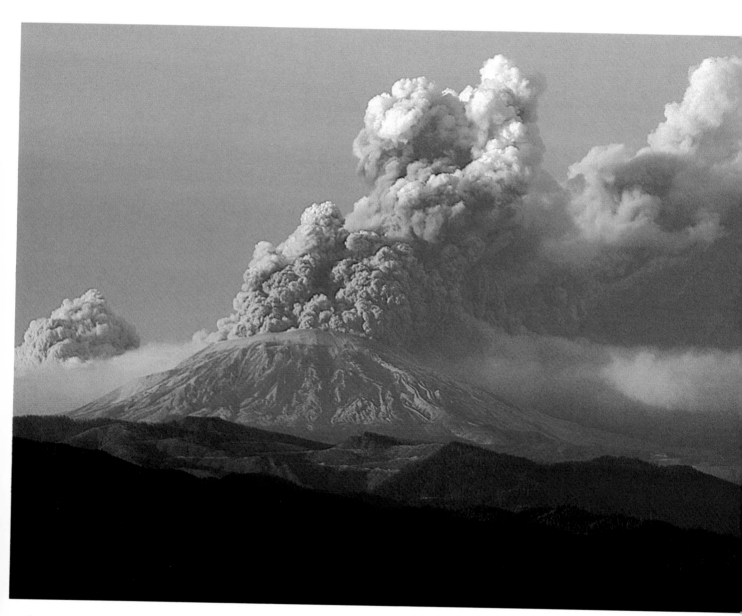

◁ The main cloud is momentarily cloaked in steam around its base during the early stages of the eruption on May 18.

△ Late in the afternoon of May 18, a second large plume (left) rose from somewhere in the vicinity of Spirit Lake.

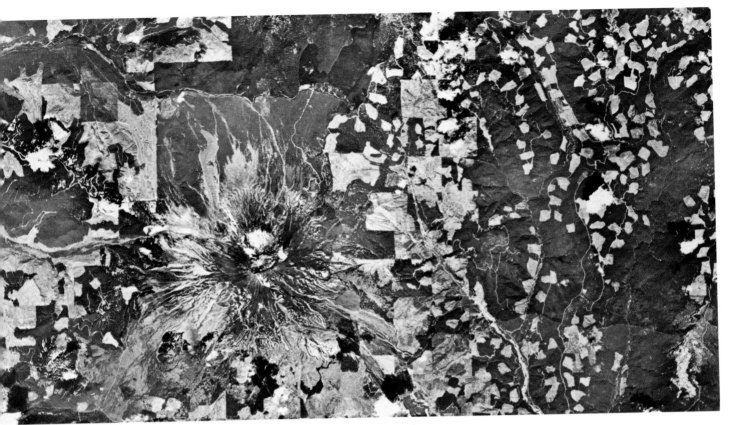

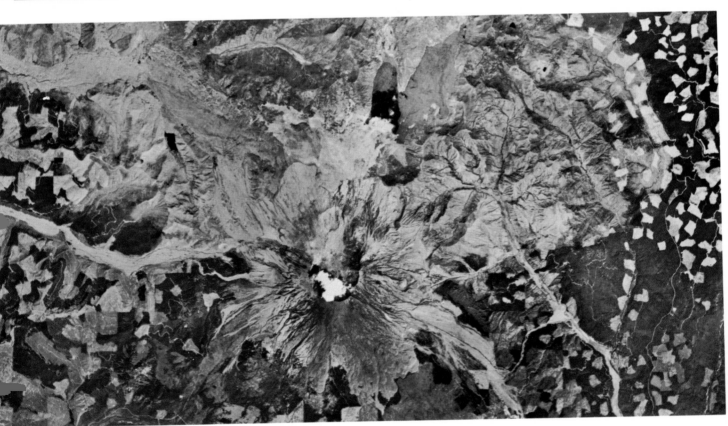

△ The changing landscape of Mount St. Helens is shown clearly in these before-and-after pictures, which were taken from an altitude of sixty thousand feet. With infrared (heat-sensitive) film, living vegetation appears red, and the dead vegetation appears purple. The rectangular patches in both photos are clearcuts from the extensive logging that had taken place in the area. The blast area and mudflows are visible in the "after" picture, but steam covers the crater.

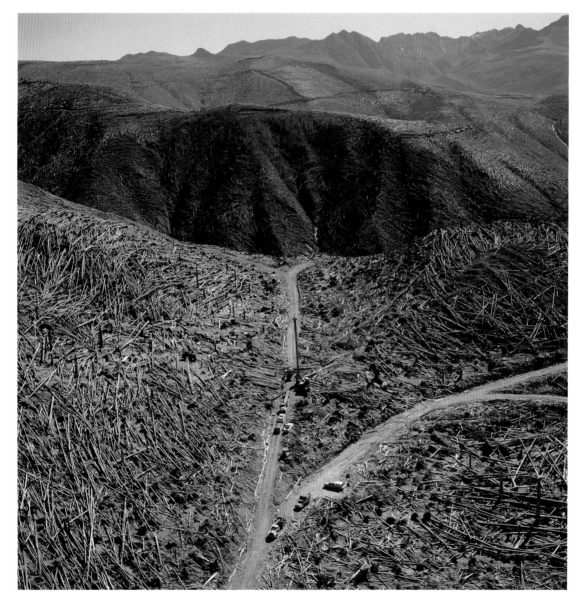

△ The Mount St. Helens blast erased centuries of forest growth in minutes, scattering mature trees that had towered some 150 feet in the air like straw blown by a fan. The power of the blast is equaled only by the power that has been demonstrated by Nature in her ability to recover.

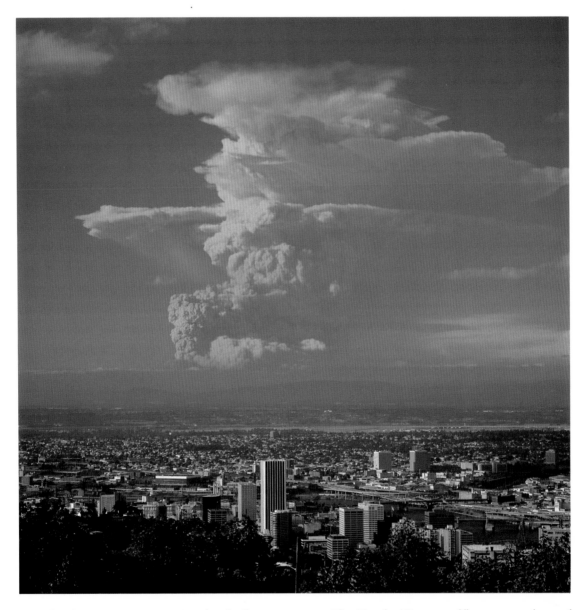

△ Ash plumes tower over Portland, Oregon. ▷ After May 18, the surface of Spirit Lake was raised over two hundred feet, but the depth is eighty feet shallower, and there are new islands.

▷ ▷ The Toutle River mudflow, a product of melting glaciers and snow, left thick mud in the valley (as viewed the following day). Resulting floods silted the Cowlitz and Columbia Rivers.

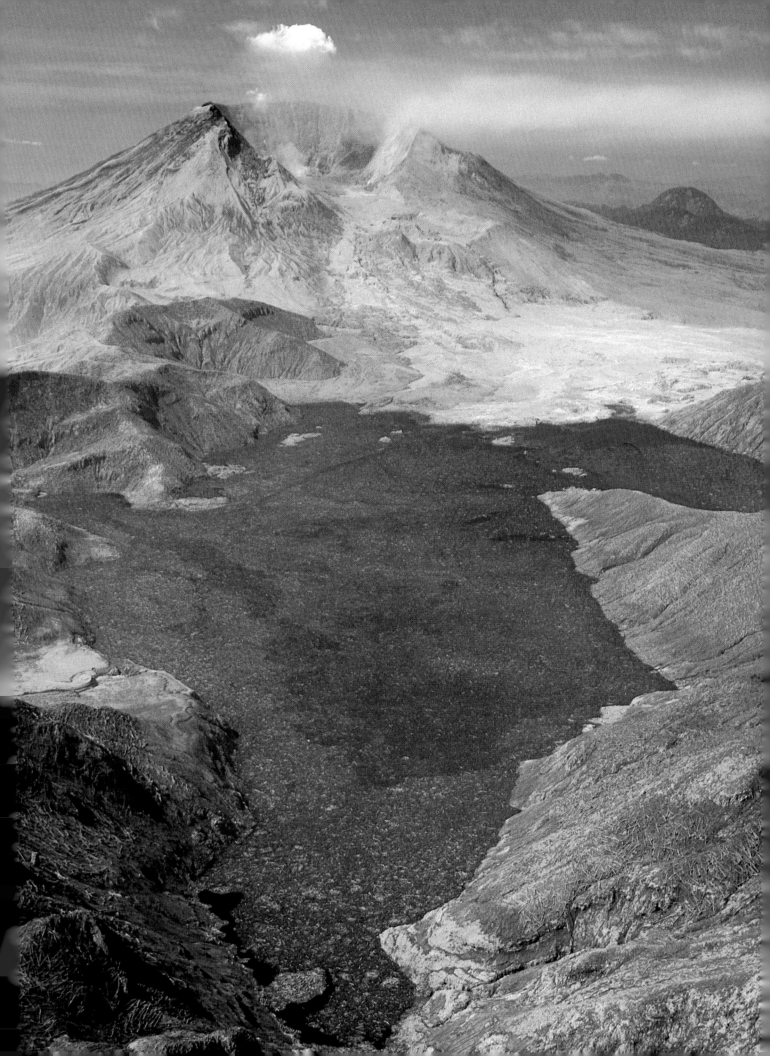

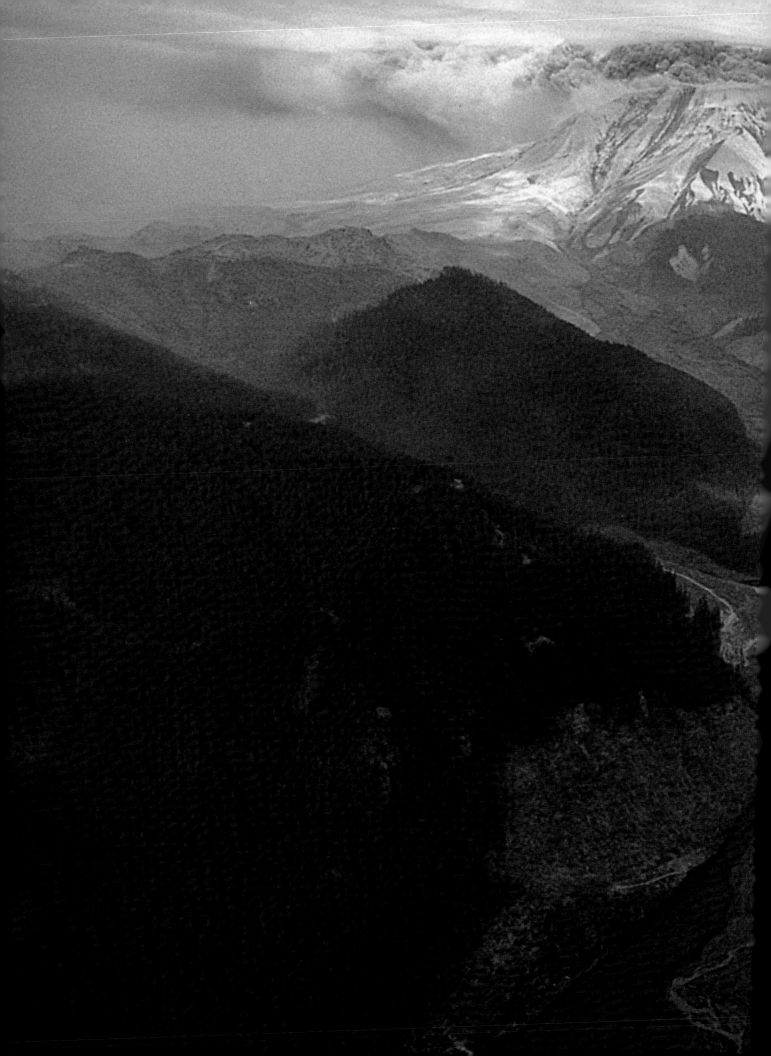

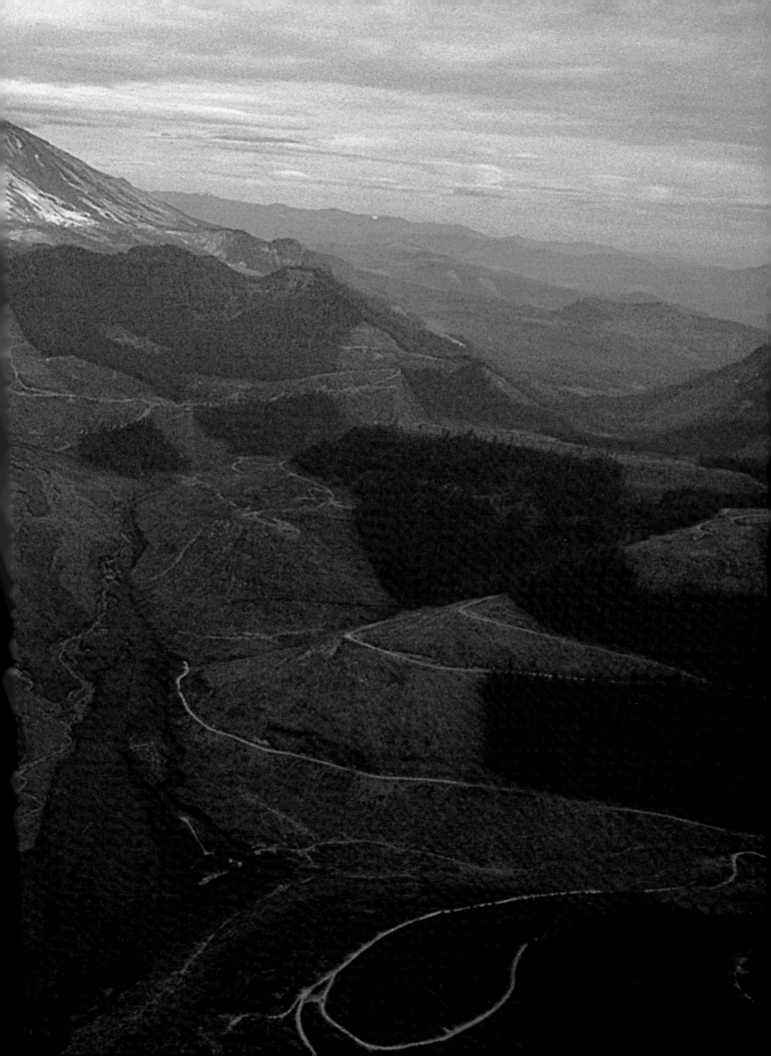

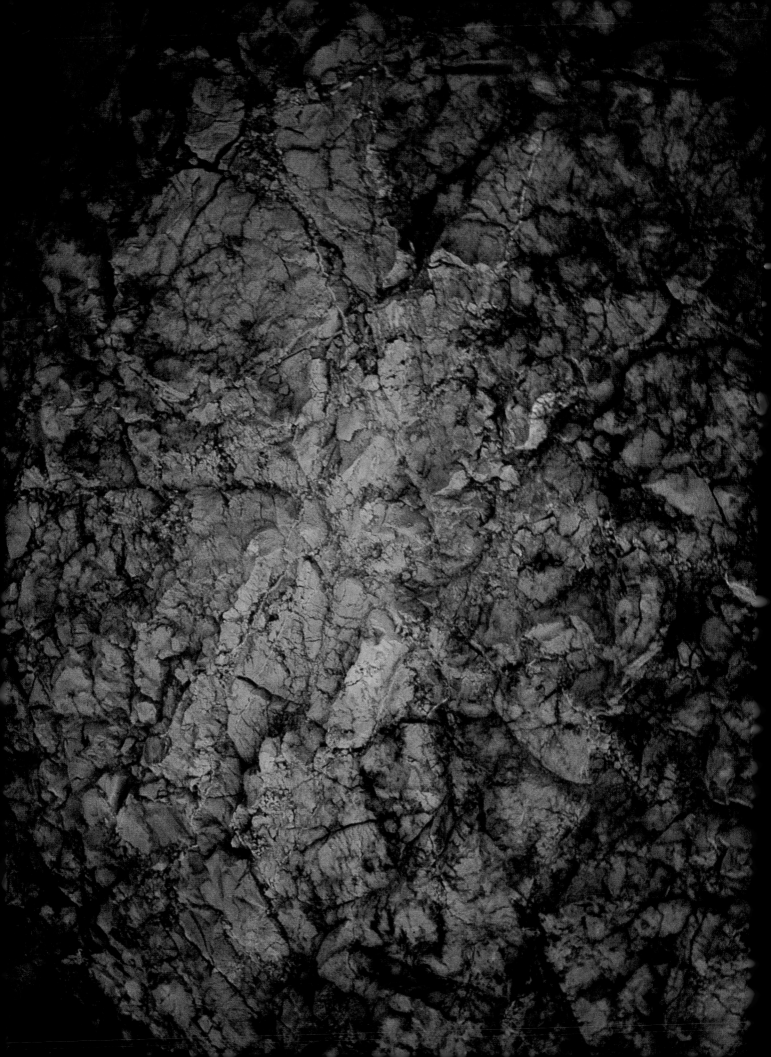

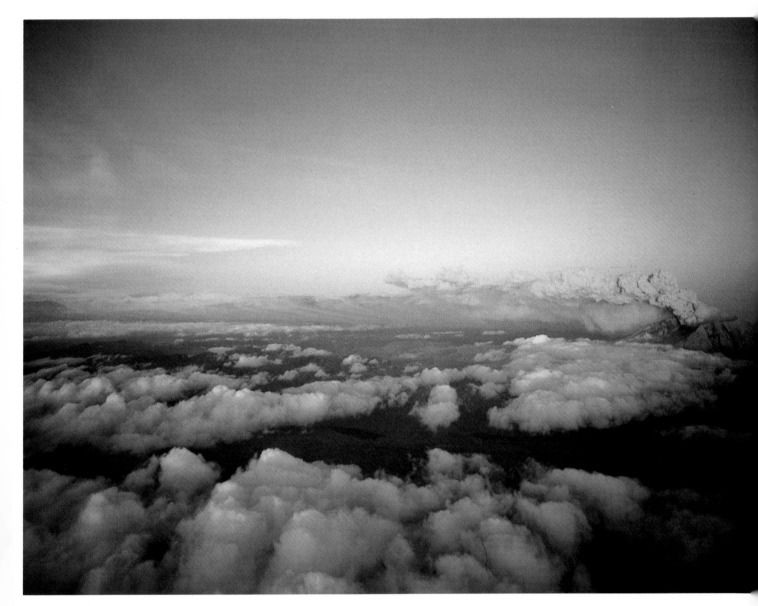

◁ Cracked by tremendous pressure beneath it, the lava dome reveals its hot, molten interior. △ An ash cloud from a mid-summer eruption drifts eastward; carried by winds aloft, it will reach parts of Canada and the eastern U.S.

▷ ▷ The symmetrical upper cone of Mount St. Helens was replaced by a huge amphitheater measuring nearly two miles long, one mile wide, and approximately four thousand feet deep. A lava dome has plugged the volcano's vent.

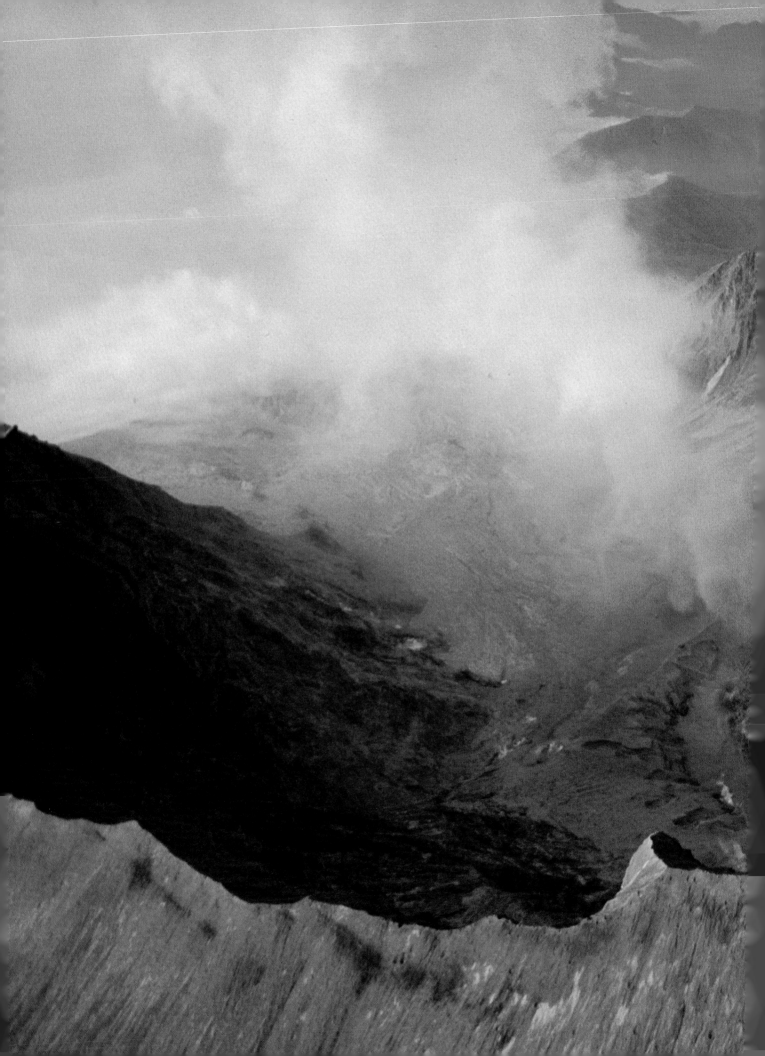

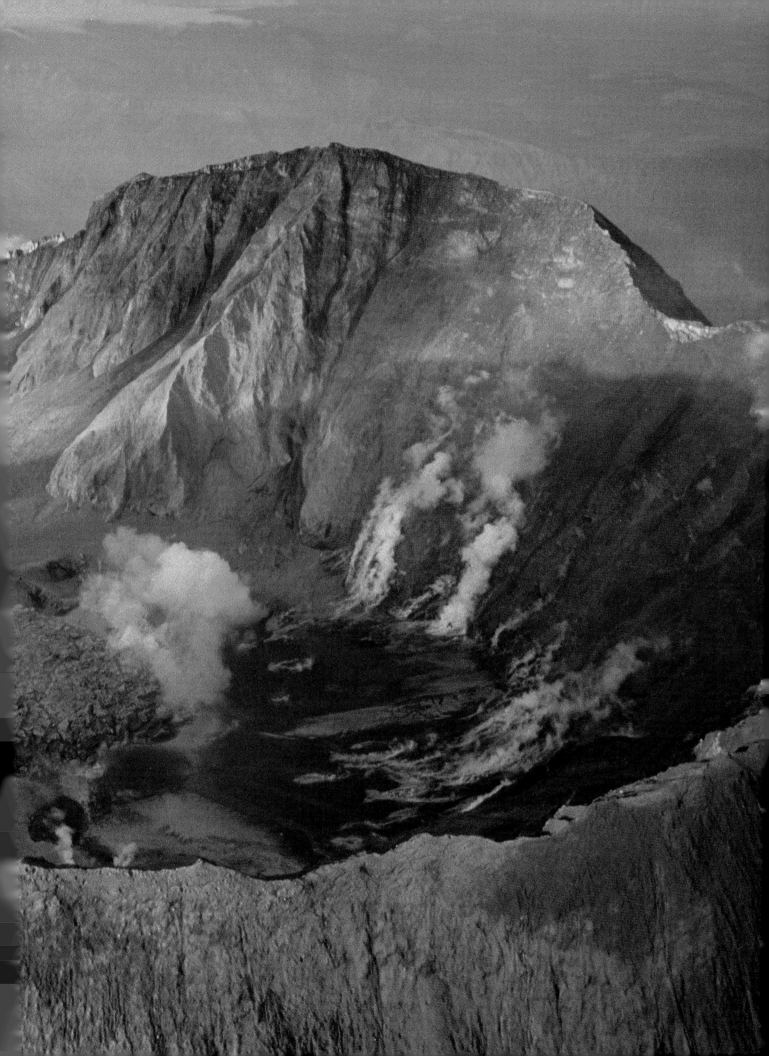

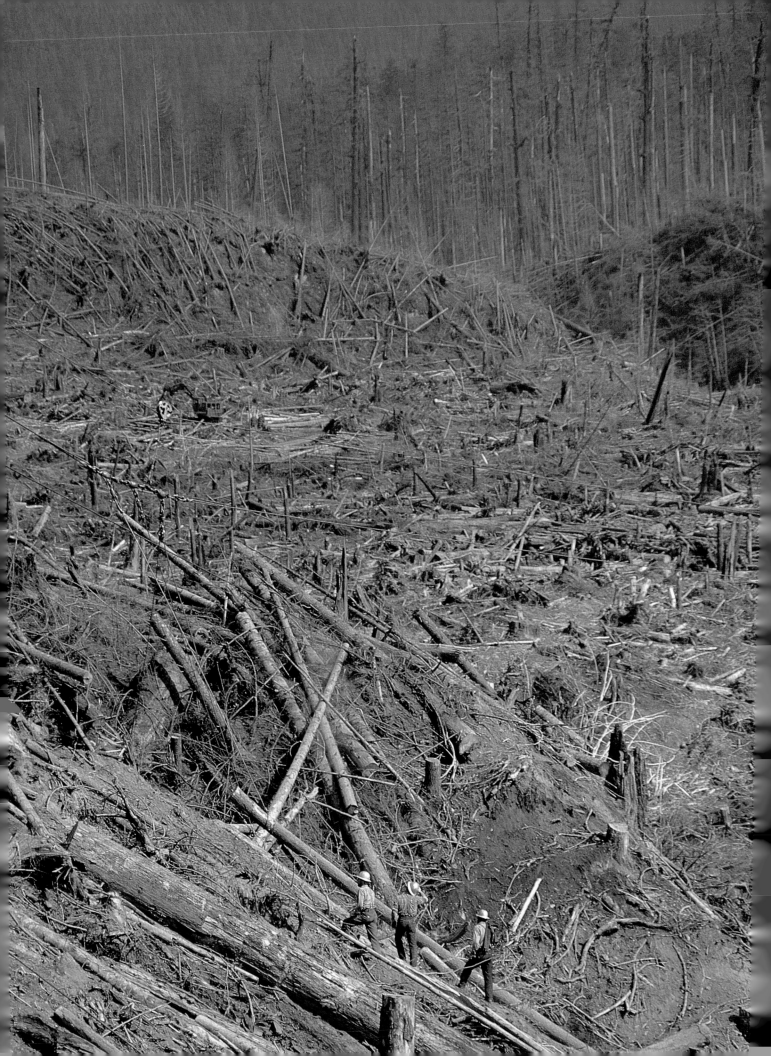

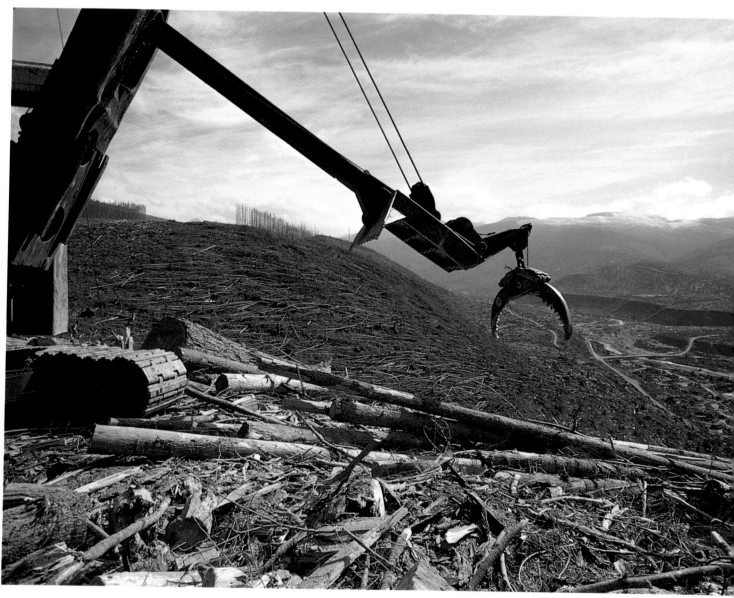

◁ The pattern of blown-down trees gave insight into the trajectory of volcanic winds. Those who bemoan these toppled forests should remember that many of them took root on mudflows spawned by an 1831-1857 eruption cycle.

△ Salvage logging and tree planting in eruption aftermath took place on land previously leased by the government to timber companies; the 110,000-acre Mount St. Helens National Monument was mostly left to regenerate naturally.

△ Hoffstadt Bluffs, a Cowlitz County–operated facility, offers travelers on the Spirit Lake Memorial Highway their first good view of the crater and the largest landslide in history. ▷ The Hoffstadt Bridge is half a mile long and 370 feet high.

On May 18, the temperature in Hoffstadt Creek reached 82°F, but trout were able to survive in cooler pools set off from the main tributary by debris. Numerous trees in this area were replanted not long after the blast to inhibit erosion.

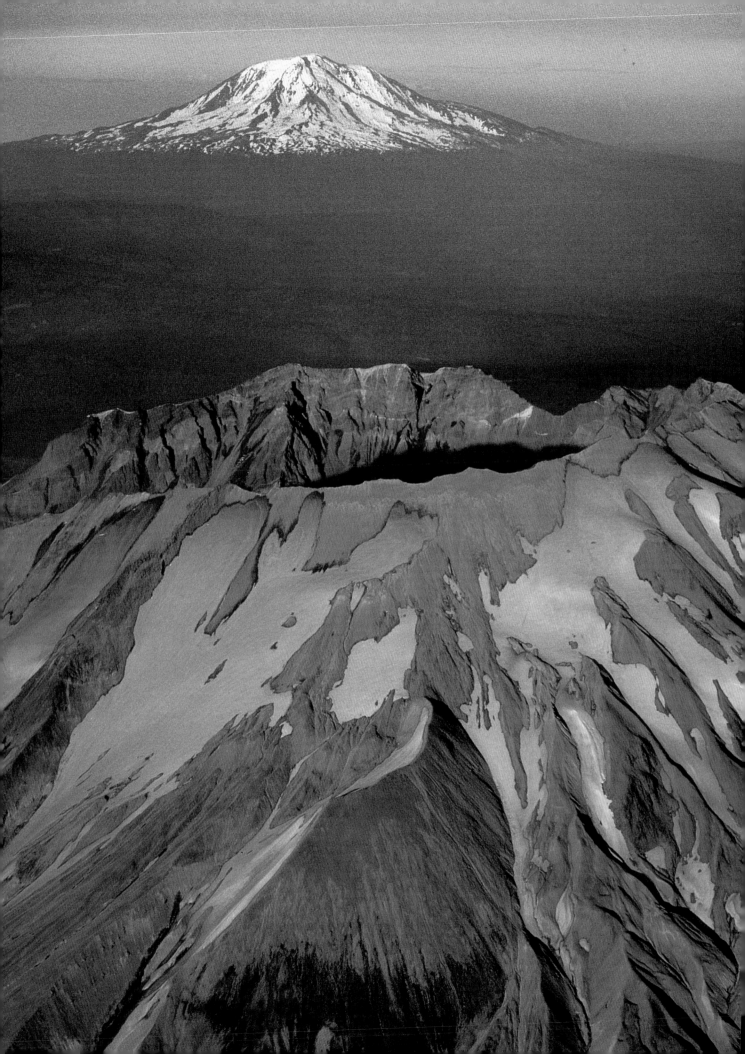

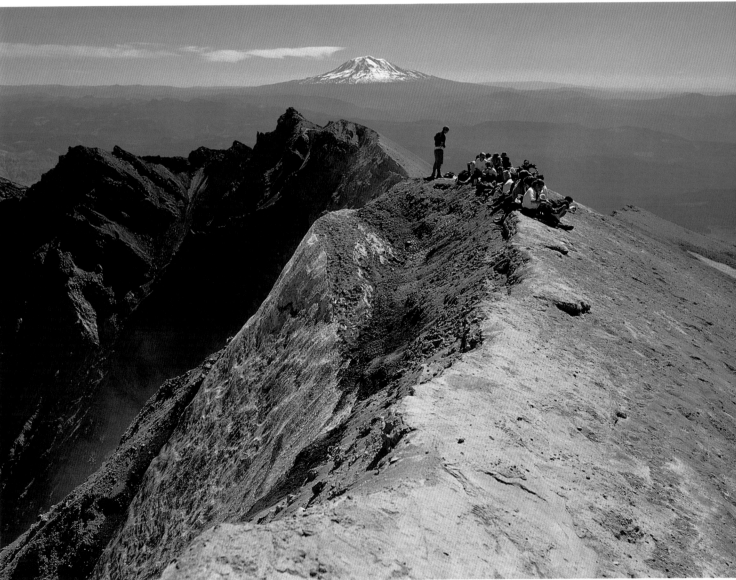

◁ Backdropped by Mount Adams, the crater is a reminder that the Cascades' snow-capped serenity may hide turmoil.
△ △ The climb to Mount St. Helens' summit is considered arduous because of the need for crampons and ice axes to negotiate snowfields, as well as the danger of sudden storms.
△ With twenty thousand climbers yearly, Mount St. Helens is the Western Hemisphere's most climbed active volcanic peak, exceeded worldwide only by Mount Fujiyama in Japan.

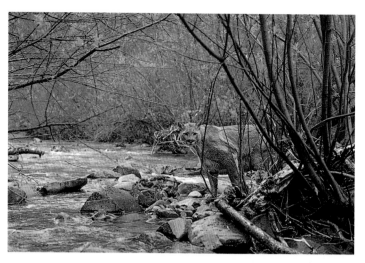

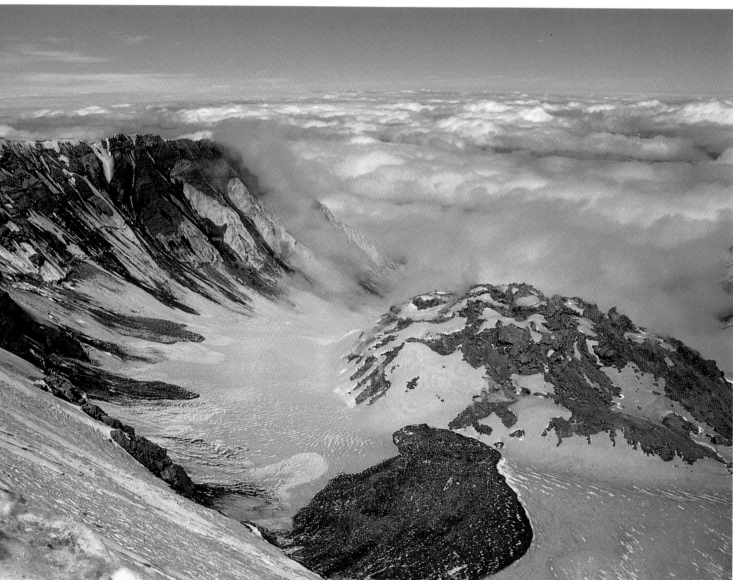

△ △ With the rise of small game populations in the Gifford Pinchot National Forest, numbers of cougar in the Toutle River Valley are expected to increase. △ The heavy consistency of silica in Mount St. Helens' lava makes it pile up over the orifice in the dome. ▷ The Weyerhaeuser Learning Center concentrates on the interaction between humankind and nature during and after the volcano's big blow. Elk herds are often observed grazing in the Toutle River Valley.

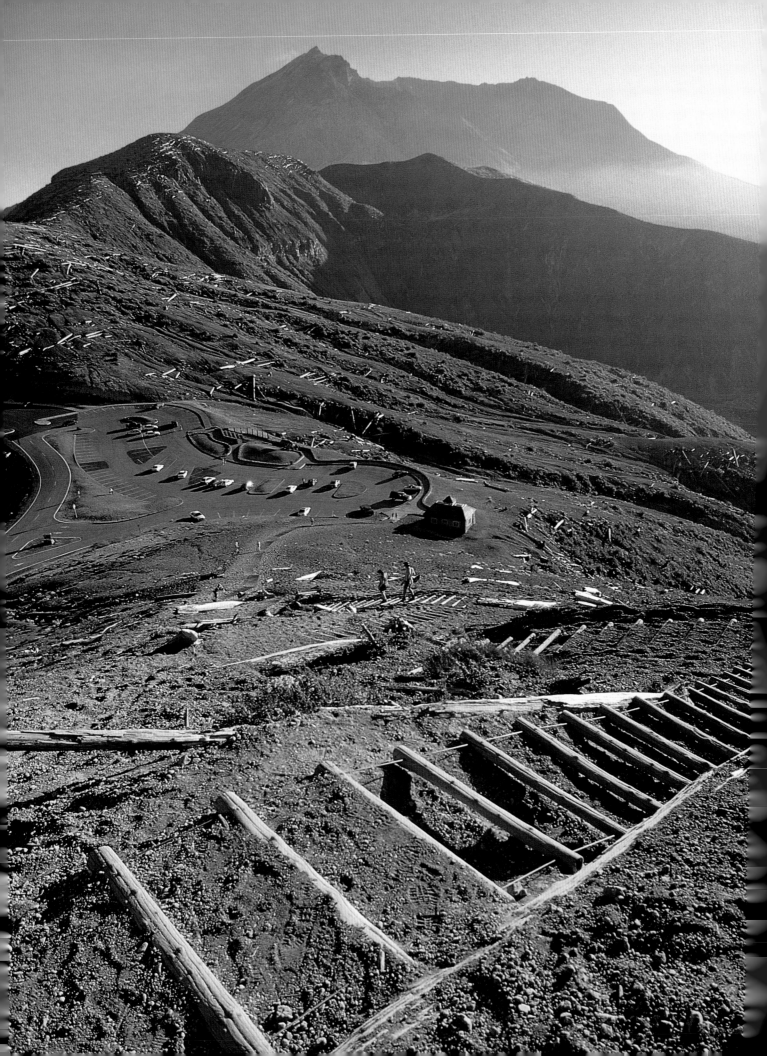

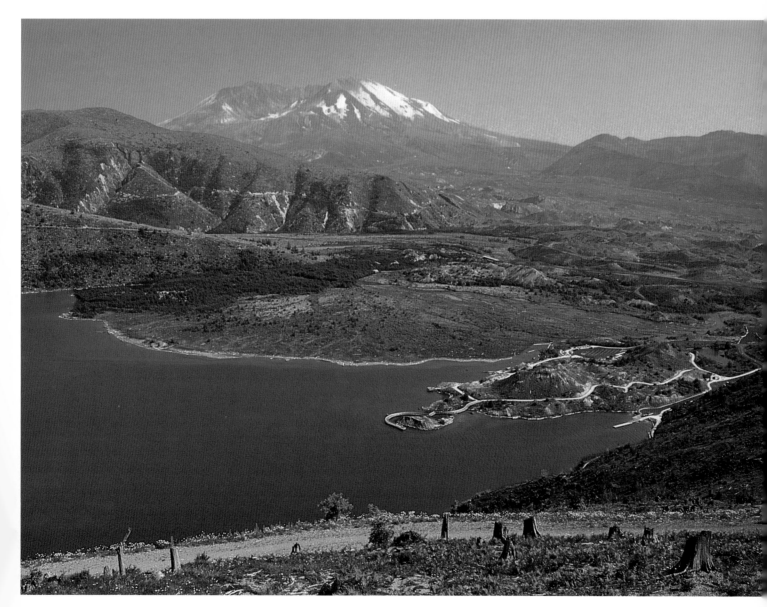

◁ Windy Ridge on the east side offers an elevated perch from which to survey a volcano-altered landscape. Those who climb the 361 steps can see the vast pumice plain bordering Spirit Lake, which nestles beneath the mountain.

△ Coldwater Lake was formed by an avalanche off the mountain's north side that dammed Coldwater Creek. An interpretive trail, boat launch facilities, and trout fishing have changed an environmental dislocation into a people-friendly retreat.

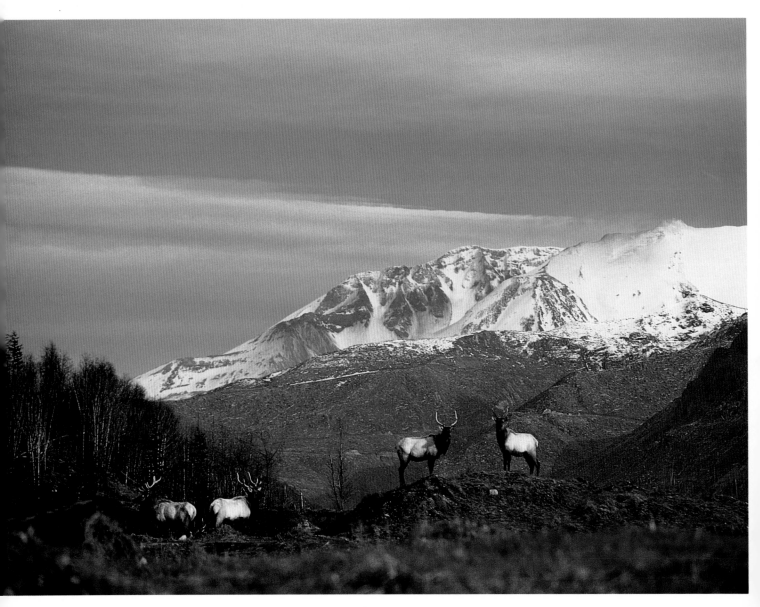

△ Due to a reduction in predators (including hunting restrictions on the avalanche debris flow) the elk population has increased threefold from pre-eruption levels. An increase in browse provides enough food to support the larger herds.

▷ Black bears were just starting to stir from their winter sleep at the time of the eruption. Despite volcano-related losses of two hundred *Ursus americanus,* a healthy bear population, based on renewed food sources, is predicted.

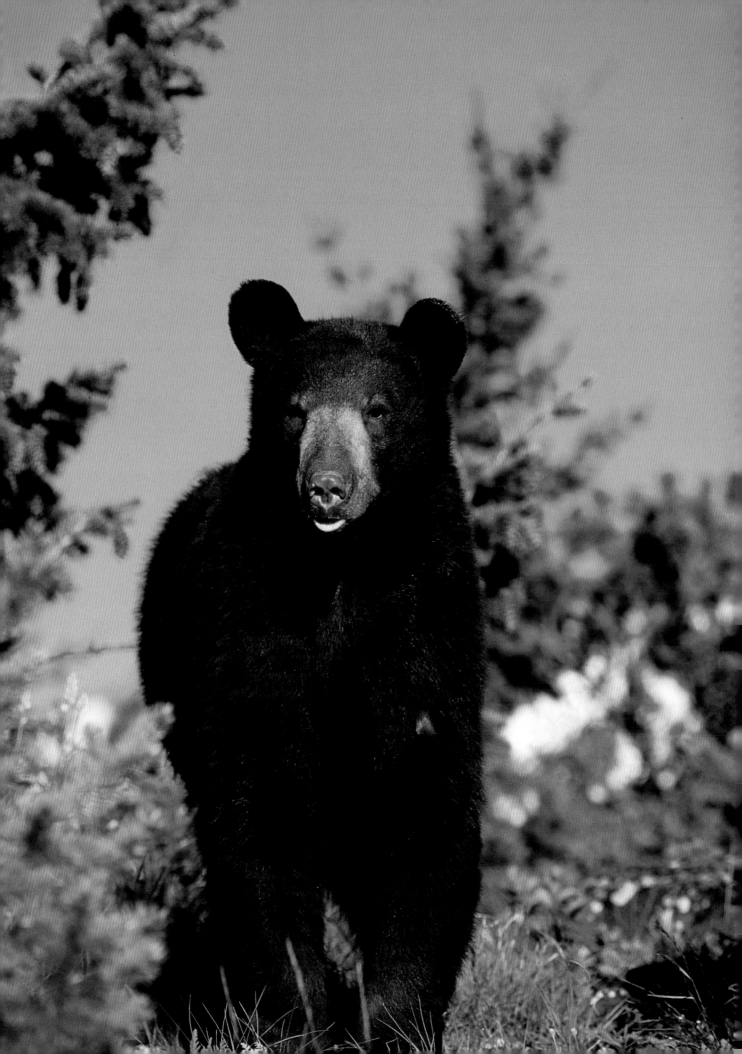

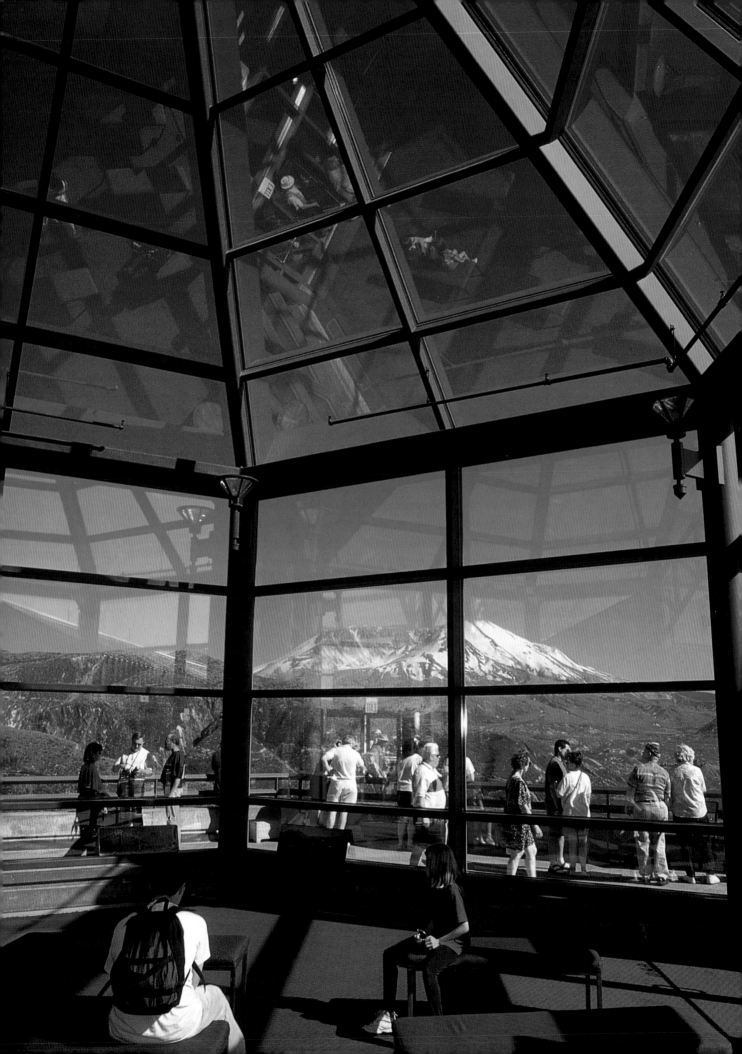

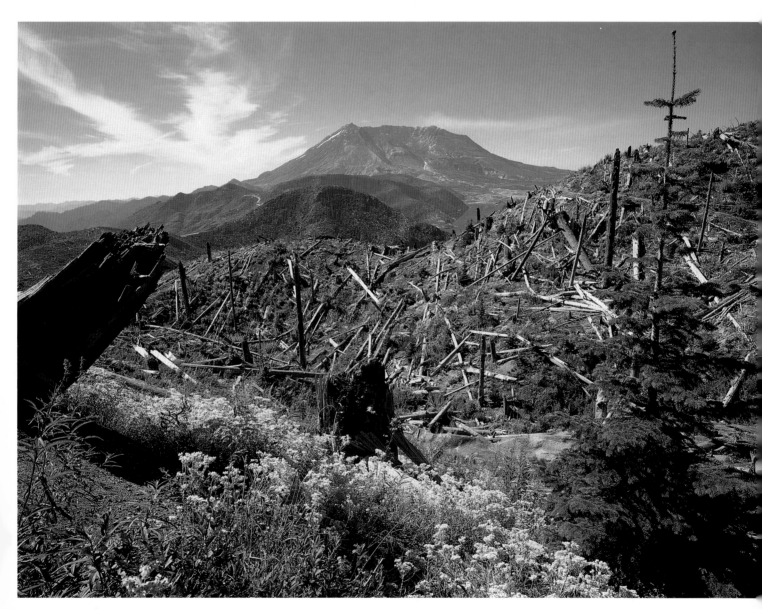

◁ The Coldwater Ridge Visitor Center offers exhibits and audio-visual presentations regarding the re-establishment of the plant and animal communities within the blast zone, as well as spectacular views of Mount St. Helens.

△ This classic post-eruption tableau showcases a landscape that is in the process of becoming. Snags, uprooted trees, a young conifer, and pioneer plants create an interesting montage of death and rebirth in the shadow of the mountain.

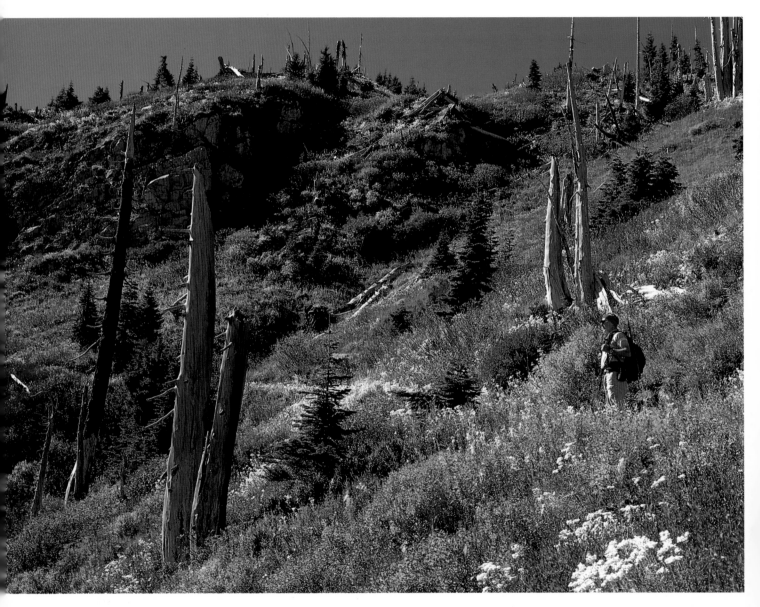

△ Snags are frequently seen below ridgelines. The raised contours of the topography here acted as buffers against the full force of the blast completely leveling a forest. The reduced canopy has opened up colorful vistas for hikers such as this one standing amid huckleberry and spiraea near Bear Pass. ▷ Forty miles from the monument, exhibits and films at the Mount St. Helens Visitor Center document eruptions past and present, as well as the ecological evolution of the land.

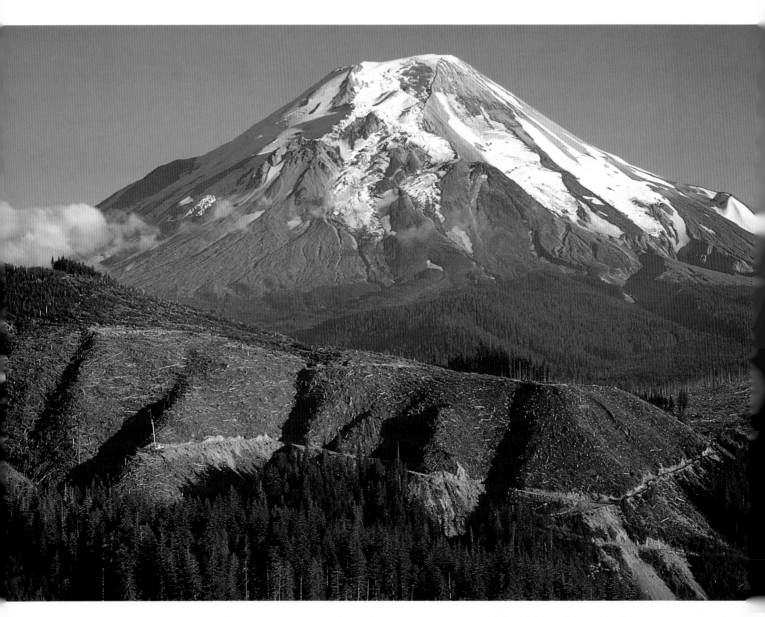

△ This pre-eruption perspective on Mount St. Helens was taken from the site of the present-day Coldwater Ridge Visitor Center. Clearcuts, cat trails, and other signs of human presence are depicted in the foreground. Both man and Nature are capable of denuding a landscape. But considering the moonscape appearance in eruption aftermath and the subsequent regeneration, we can take heart from the resiliency demonstrated by the ecosystem of Mount St. Helens.

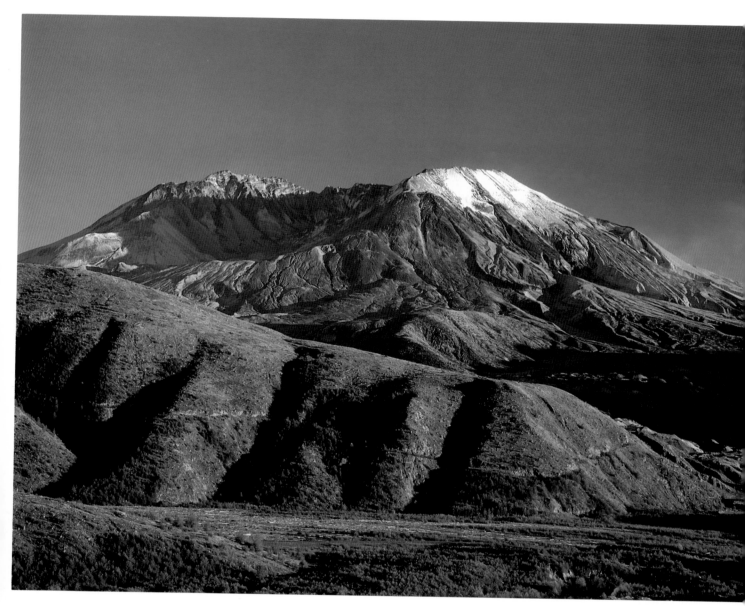

△ A post-eruption glimpse from the same point as the previous photo depicts barren hills, an open volcano crater, and a mountain peak missing thirteen hundred feet off the top. ▷▷ Young conifers are now starting to appear on the lower slopes of Mount St. Helens once again. While perhaps only our children's grandchildren will have the privilege of seeing and enjoying the lush green forests we once enjoyed, these young trees offer a life-affirming look at Nature on the mend.

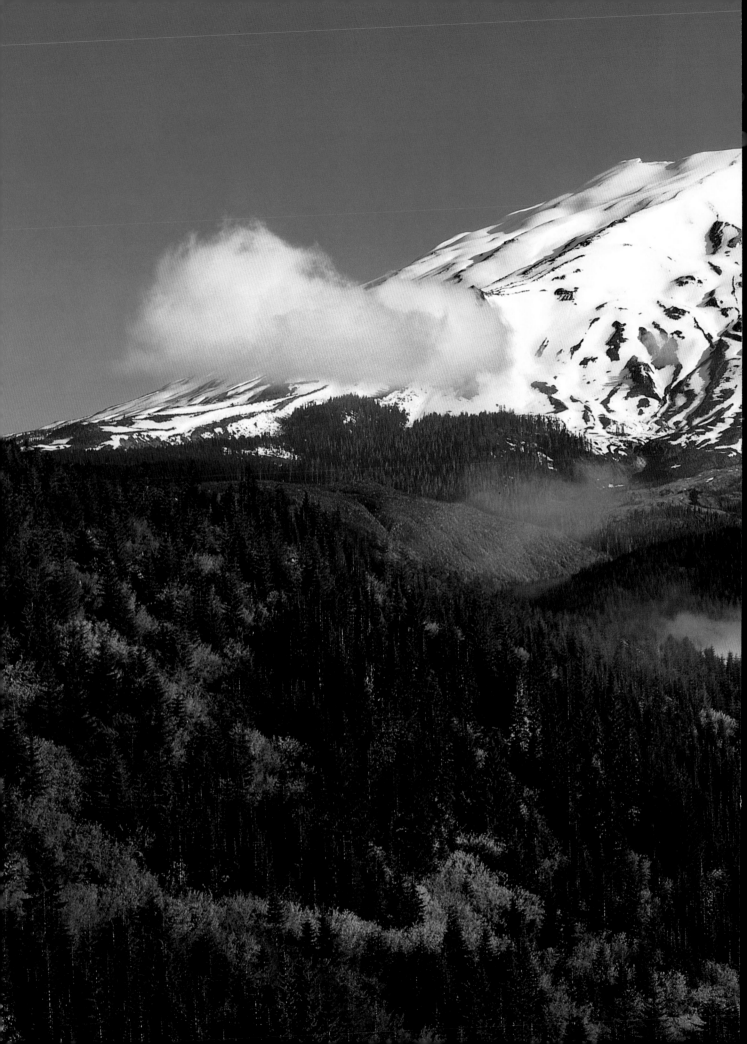

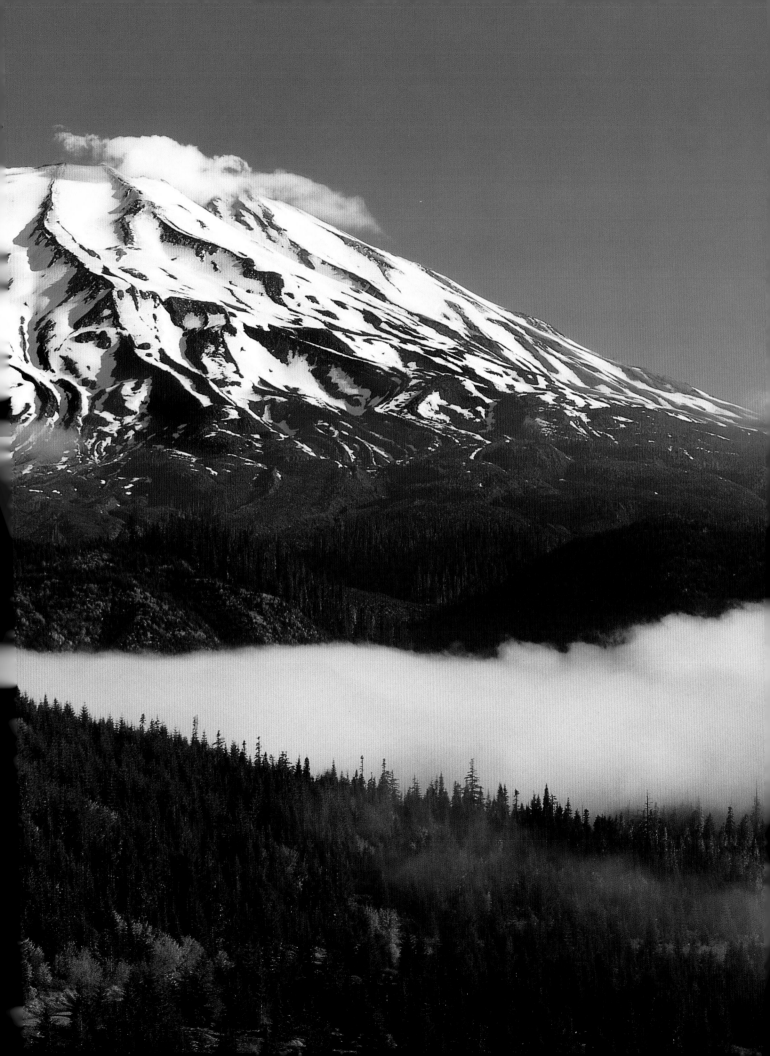

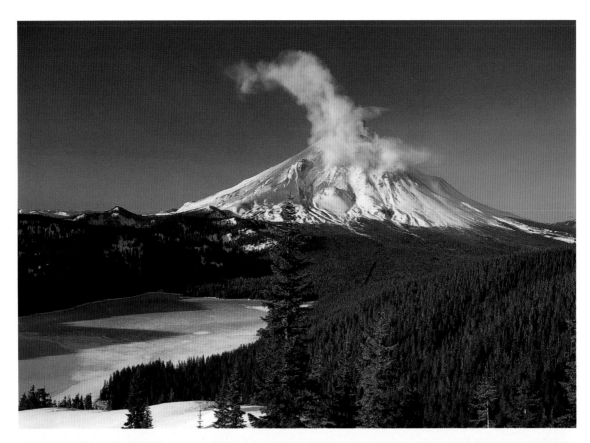

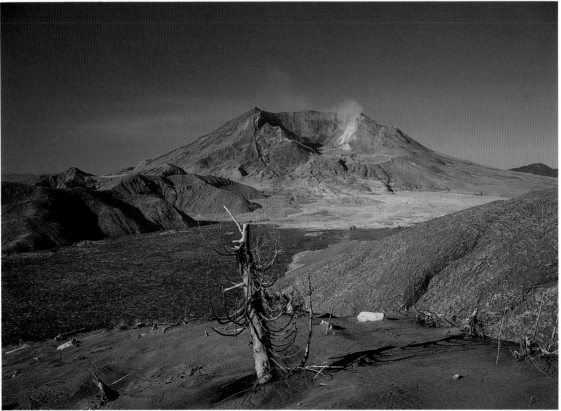

△ The photos on these two pages depict the landscape's evolution north of the mountain. The first frame shows the mountain's snow-capped symmetry on April 12, 1980; the second shows an open crater and a log-filled Spirit Lake on June 30. The facing page focuses on pioneer plants that broke ground in the post-eruption moonscape, culminating September 28, 1996.

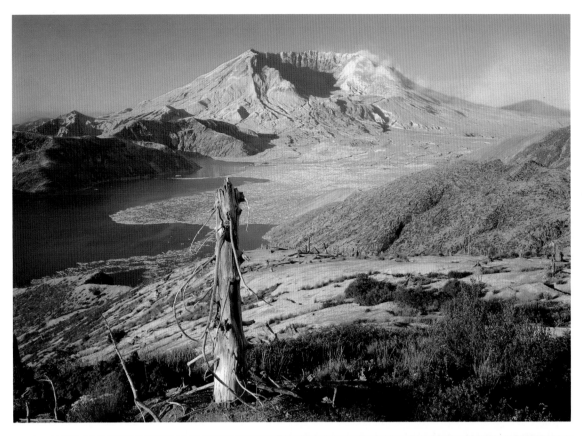

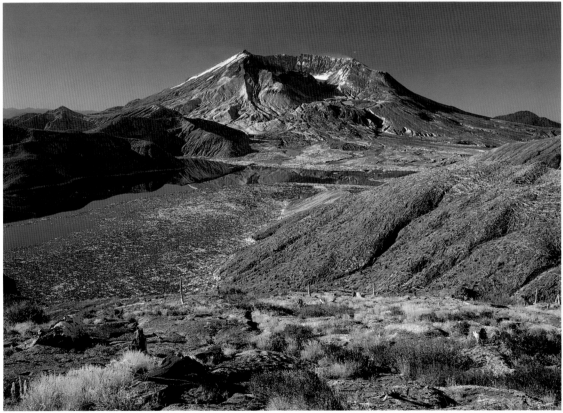

▷ ▷ In winter, the mountain's repose belies its cataclysmic past. While the forces that created the last eruption cycle have not gone away, let us not forget that some of the first organisms on the planet were incubated by a combination of gases paralleling those in the mountain, that volcanic soils are among the world's most fertile, and that volcanoes are as much creators as destroyers.

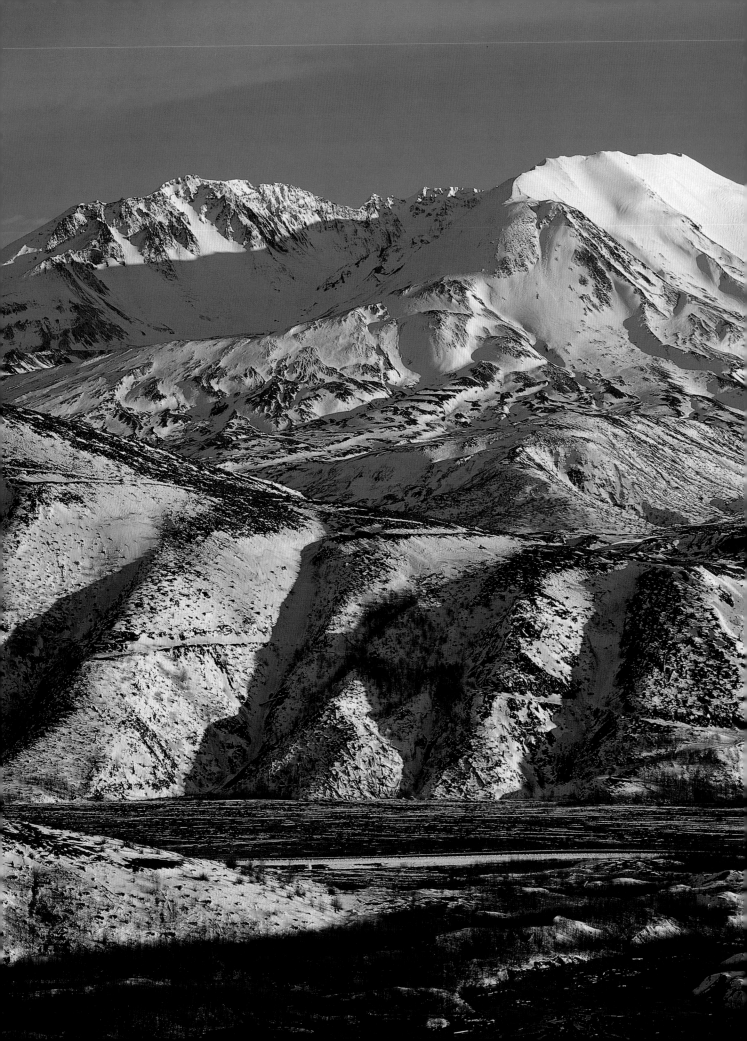